IMAGES
of America

EAGLE ROCK

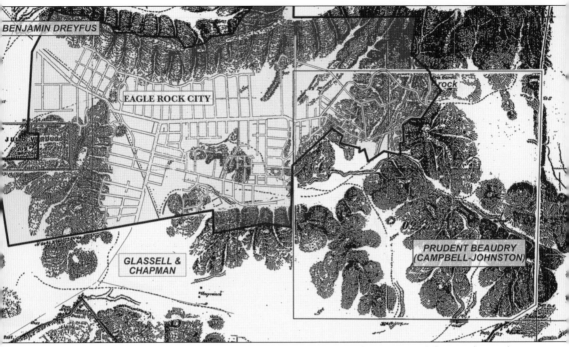

RANCHO SAN RAPHAEL, CITY OF EAGLE ROCK. This geographic map is of the rancho at the time of the great partition in 1871. After a long passage through the courts, the ownership of Julio and Catalina Verdugo's land was decided and Julio's debt was discharged by the division and sale of his land. The new owners of the Eagle Rock area were Benjamin Dryfus, Glassel and Chapman, and Prudent Beaudry. Overlaid is the city of Eagle Rock at its incorporation in 1911. The names of the streets are now all different but the basic pattern was in place.

ON THE COVER: The photographer is standing on what will become Figueroa Street at about Lanark Street in 1897. In the middle distance is the Stewart ranch. The Eagle Rock is seen in profile. The brows of the shallow cliffs on the rock face can be clearly seen but the shadows forming the eagle are not visible. Native sycamores in the center indicate the path of the stream. In flood times, it would probably cross directly in front of the viewer to head down the Yosemite Valley. (Courtesy Eagle Rock Valley Historical Society.)

IMAGES
of America

EAGLE ROCK

Eric H. Warren

To Jean
A good neighbor.
All the best,
[signature]
12/10/09

ARCADIA
PUBLISHING

Published by Arcadia Publishing
Charleston SC, Chicago IL, Portsmouth NH, San Francisco CA

Printed in the United States of America

Library of Congress Control Number: 2008935199

For all general information contact Arcadia Publishing at:
Telephone 843-853-2070
Fax 843-853-0044
E-mail sales@arcadiapublishing.com
For customer service and orders:
Toll-Free 1-888-313-2665

Visit us on the Internet at www.arcadiapublishing.com

*To Henry Welcome, the founding president of
the Eagle Rock Valley Historical Society,
and all who made this book possible
by their years of dedicated collection and
preservation of Eagle Rock's history.*

CONTENTS

ACKNOWLEDGMENTS

Thanks first go to Karen, my wife, friend, and lover, who keeps it all together and edits my copy. Thanks also go to all of the archives and individuals who contributed photographs, documents, and memories used in the compilation of this book. Unless otherwise credited, all photographs are from the archives of the Eagle Rock Valley Historical Society. Credits refer to photographs only unless otherwise noted.

Thanks are deserved by the following, whose help made compiling this book a pleasure: Josie Dapar, Leslie Fisher, Henk Friezer, Joan Graham, Ross Landry, John Miller, Trevor Norton, Jean Paule, Dave Porter, Sarah and Corey Stargel, Dale Ann Steiber, Katie Taylor, Alan Weeks, and the folks at Warner Brothers Photo Lab.

Finally, thanks go to all those whose contributions have immeasurably enhanced our understanding of the sweep of our history and advanced the continuing development of our community. The writing of history is complex and nuanced; any errors or opinions expressed here are solely my own.

INTRODUCTION

People first came to Southern California about 10,000 years ago. Around 2,000 years ago, the Tongva people, speakers of a Uto-Aztecan language, slowly displaced earlier native groups, adopting their life ways. Gathering and hunting, they learned how to live on this sometimes harsh but beautiful and nurturing land, making a vibrant culture with the plant material and stone available in the area or by trade with their neighbors. Consistent sources of water and oak woodlands provided people with the basics of life. They were monotheistic and reverently bathed daily to greet the sunrise. Their first friendly encounters with Europeans caused them much suffering, as they had no immunity to exotic diseases brought by explorers.

In the mid-1700s, the empire of Spain consolidated its claim on California. The Mission San Gabriel was established in 1771 to settle this "wild" land. The padres worked to save the native souls, whose labor was needed to impose a European way of life on the landscape. For the first time, a large population required permanent support.

In 1784, for loyal army service, Jose Maria Verdugo received from Gov. Pedro Fages a grant of 36,403 acres west of the Arroyo Hondo (Seco) for stock raising and ranching to produce for the empire. Gov. Diego Borica Retegui confirmed his title to the Rancho San Rafael in 1798.

In 1821, sovereignty over California was transferred to Mexico, which secularized the mission lands. Though they nominally held title, the native people were quickly deprived of its benefits. They became a source of badly paid and exploited labor both under the Mexicans and later the Americans. Only lately has their culture begun to recover from this sad situation.

Verdugo and the other Californios lived well in good times and subsisted in bad on their vast tracts. Verdugo died in 1831, willing the Rancho San Rafael to Julio and Catalina, two of his 10 children. Catalina was blind, so Julio controlled the rancho. In 1847, Californios fighting the occupation of California by the Americans surrendered to Fremont at Casa de Cahuenga.

In 1861, Julio mortgaged his family's land for $3,445, probably to build a house. The loan cost 3 percent per month, compounded every three months. After six years, the rancho passed from the Verdugo family, at a foreclosure sale, into the ownership of Alfred Beck Chapman for $58,750, the mortgage amount owed by Julio. Chapman quitclaimed to Julio Verdugo 200 acres surrounding his adobe and put the rest up for public auction.

Benjamin Dreyfus purchased what was to become most of Eagle Rock; this area was opened to farming by the Watts subdivision in 1886. Prudent Beaudry bought the area between what is now Loleta Avenue and the west side of the Arroyo Seco. He soon sold this area to Alexander Robert Campbell-Johnston, who subdivided it later.

Surrounded by hills, the Eagle Rock Valley at the end of the 19th century was a rural area far removed from the bustling city. At the time, truck farms, including the Gates Strawberry Ranch, worked by Chinese laborers, covered much of the area. Grand Victorian farmhouses stood on the slopes, and more humble houses and barns populated the valley. With the founding of the Union Church and the Women's Twentieth Century Club, the small population began its cultural organization.

The arrival of the Los Angeles Railway in 1906 made suburbanization of the valley possible. The tracks came from downtown Los Angeles along Central Avenue (now Eagle Rock Boulevard) and extended to the intersection of Townsend Avenue and Eagle Rock Road (Colorado Boulevard), the heart of town at the time. A local line ran to Glendale and Montrose. Another line ran down Figueroa Street and up to the Eagle Rock to supply the Edison power station and serve the verdant area known as Eagle Rock Park.

With the new transportation, a more suburban Eagle Rock began to appear. Craftsman-style homes and public buildings such as the Women's Twentieth Century Club exemplified the times. The Eagle Rock Carnegie Library, various lovely churches, and many attractive brick commercial buildings were constructed along the boulevards. A wide range of housing allowed a diverse population to make homes. Occidental College, designed by Myron Hunt in the Mediterranean Revival style, opened in the York Valley in 1914.

Eagle Rock was incorporated as a city in 1911. A spirit of boosterism and small-town sociability prevailed. To its residents, Eagle Rock still felt rural. Children walked through orchards and past grazing cattle to school. The increase in population led to a more citified style. In 1923, not long after the Eagle Rock City Hall was erected, the people of Eagle Rock voted to become part of the City of Los Angeles under the threat of an inadequate water supply and the promise of an upgraded school system.

The 1920s upswing in construction included many houses built in period revival styles, such as Italianate, Spanish, Colonial Revival, and English Tudor. San Rafael, Dahlia Heights, and Rockdale Schools were expanded and Eagle Rock High School and Delevan Drive School were built to accommodate the growing population. The Carnegie library was expanded and remodeled. The end of the decade saw construction in the new Art Deco fashion before the worldwide Depression put an end to prosperity.

World War II transformed Eagle Rock, bringing the town more than ever into the context of the city and the region. Many veterans settled here after their first glimpse of California on their way to battle. The Stimpson Lemon Ranch, the last large farm, and the remaining empty lots filled with mid-century modern houses. Retail businesses remodeled to stay in tune with the times and capture what proved to be the final period of prosperity for the traditional main street.

The 1950s brought momentous changes. The trolley tracks were torn out, and the freeway bridge was completed over the Arroyo. The last dreams of a park in the valley of the Eagle Rock died as the dump road, reservoir, and freeway off-ramp all were built, obliterating much of this natural area. A part of that dream was resurrected when Eagle Rock Recreation Center with its Neutra-designed clubhouse was built on the nearby knoll. Changes in shopping habits gave rise to mall construction and put an end to many mom-and-pop stores.

Demographic and social change came with the end of legal segregation in 1964. This, coupled with the movement to the suburbs of the boomer children, brought a new population to town. The struggle to prevent the building of the freeway through the center of the valley galvanized the community. The strong loyalties of old and new residents sustained quality schools and vibrant culture. New regard and understanding of the value of quality housing stock, city adjacent location, and potentially walk-able commercial areas began reviving and refreshing Eagle Rock. Citizens have rededicated themselves to sustaining the tradition of "L.A.'s Hometown."

One

BEFORE THE RAILS

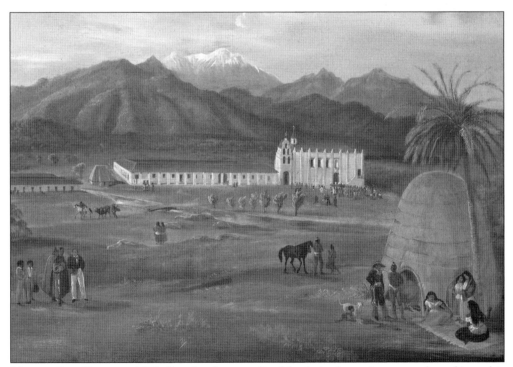

MISSION SAN GABRIEL, 1832. People who once lived freely in the region were adopted into this outpost of Spain. Typical Tongva architecture, men in traditional dress, and women in mission style are shown at lower right. In the left rear are native convert labor quarters. The Tongva culture has been revived in recent years, and these first Angelinos now speak for themselves. (Painting by Ferdinand Deppe, courtesy Santa Barbara Mission Archive Library.)

SIGNIFICANT SITES, RANCHO SAN RAFAEL. Jose Maria Verdugo, a corporal in the Spanish army, was granted the Rancho San Rafael by Gov. Pedro Fages in 1784. In the foreground is the "Pico oak" where in 1847 Gen. Andres Pico met with his brother Jesus, a prisoner of war and emissary from General Fremont, to discuss the terms of Mexico's surrender of Southern California. To the right rear is Catalina and Julio Verdugo's adobe. The location is now in Glendale. (Courtesy Glendale Public Library Special Collections.)

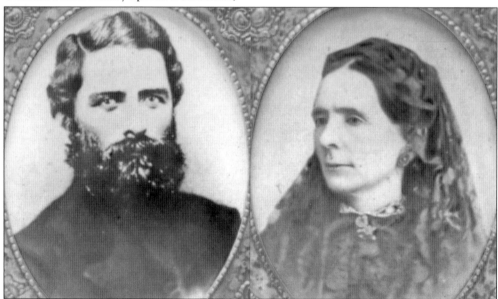

SHERIFF TOMAS SANCHEZ AND MARIA SEPULVEDA SANCHEZ. He became sheriff of Los Angeles County in 1859 after putting down a rebellion by Juan Flores, an escaped convict, who killed the previous sheriff, Jim Barton. Displaced from his land in the Baldwin Hills, Sanchez retired in 1872 on part of the land owned by Catalina Verdugo. His wife's foster mother was Verdugo's niece. Their house is now in Glendale on Dorothy Drive. (Courtesy Glendale Public Library Special Collections.)

PIEDRA GORDA BY AUSTRIAN ARCHDUKE LUDWIG LOUIS SAVATOR. He visited the Eagle Rock valley in 1876, making this drawing, later printed in his travel memoir *Flowers from the Golden Land* with this commentary (translated by Margaret Wilbur), "The Piedra Gorda towering above is an imposing rock of granite conglomerates on one side with exposed parallel strata having two sharply defined hollows in which swallows have built their nests." (Published by Auto Club of Southern California.)

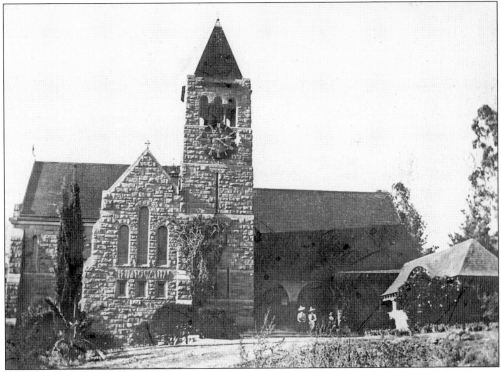

CHURCH OF THE ANGELS. The most prominent remaining structure of the Campbell-Johnston Ranch, which extended from Peyton (Loleta) Avenue to the Arroyo Seco, was constructed in 1889 by Mrs. Frances E. Campbell-Johnston as a memorial to her husband who had died on the ranch in 1888. The plans were drawn by English architect Arthur Edmund Street and adapted by Ernest A. Coxhead. Alexander Robert Campbell-Johnston had purchased Prudent Beaudry's portion of the Rancho San Rafael in 1883. (Courtesy Elena Frackelton Murdock family.)

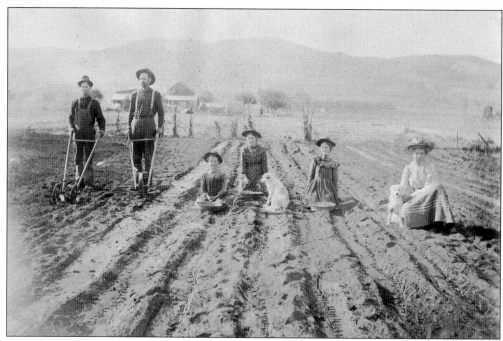

WORKING ON WHITE RANCH. Above, the men are preparing the ground to plant onions; Mr. White is second from the left. The Whitney girls are setting out the onions, and Lottie White holds her dog at the right. The ranch buildings are in the middle distance. The hills in the far distance are on the west side of Eagle Rock Boulevard. The ranch was below Yosemite Drive between Eagle Rock Boulevard and Yosemite Park. Below, the Whites and a young man are preparing peaches for market. They were halved, pitted, skinned, dried, and shipped to the East via Los Angeles. (Both courtesy Elena Frackelton Murdock family.)

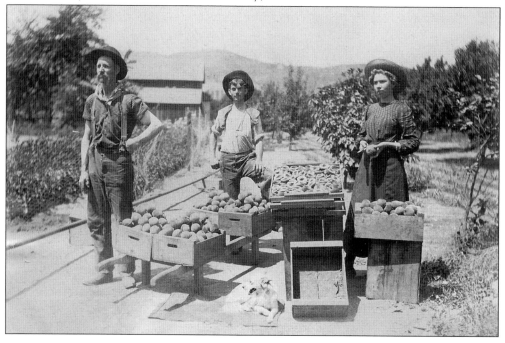

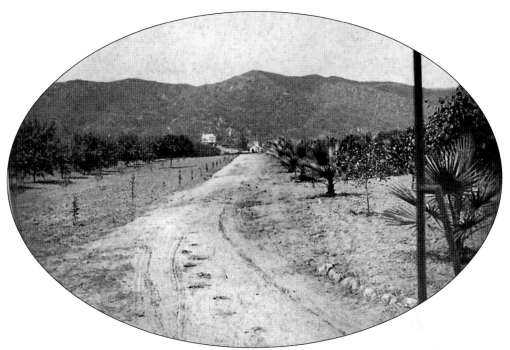

ESPERANZA, THE HICKSON HOUSE. Built in 1888 by John and Mary Hickson, the house was headquarters for a large farm extending from the ridgeline to Colorado Boulevard. The photograph below shows the house with its commanding view of the valley. At right is the road that became Mount Royal Drive, when the land was subdivided. The house still stands today. (Both courtesy Elena Frackelton Murdock family.)

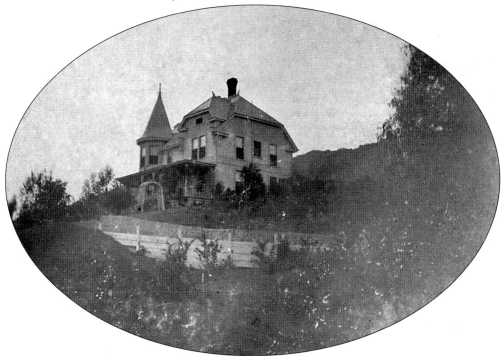

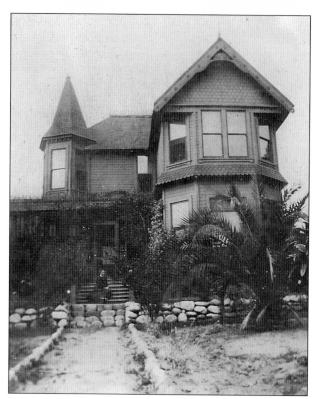

PARKER PROPERTY, DAHLIA DRIVE. The house was named Rosemont Villa for the prize roses grown on the hill around the house. Phillip Walter Parker organized the Eagle Rock School District and was trustee from Eagle Rock of the Union High School District. With Edgar D. Goode and James W. Gates, he was instrumental in bringing Huntington's trolleys to Eagle Rock. His wife, the former Ruth M. Orchard, depicted on the steps at left, held the first Sunday school in the parlor. Their fountain was the first "swimming pool," and the avenue below their house became the first "park." The band used to practice there on Sunday mornings; their specialty was "Stella." As the band members were from many families, "Stella" was well sung and whistled. (Both courtesy Elena Frackelton Murdock family.)

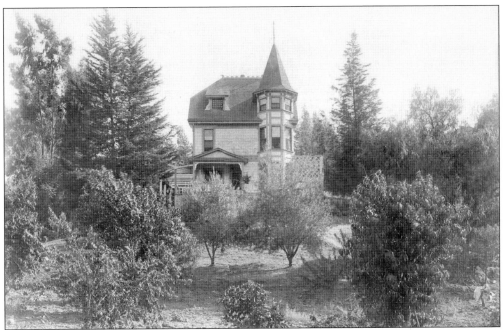

CASTLE CRAG, C. 1900. The house was built in 1888 by Howard M. Sale, a druggist. This photograph was probably taken before Edward S. Ellis subdivided the property in 1906. The house faces north to Colorado Boulevard, where the property originally ended. Eagle Rock City pioneers Charles W. Young and his wife, Emma, owned the house for many years. The Eagle Rock Plaza is now on a large portion of this land. (Courtesy Louanna Clark.)

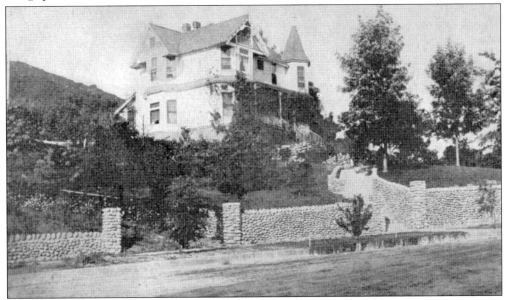

THE BROXHAM/COOK HOUSE. Built in the 1890s by Mr. and Mrs. John Broxham, the house still stands on Hill Drive today. The land was watered by a spring from a cave dug into the hills. W. J. Cook, who resided in the house in 1909, was the president of the Eagle Rock School Board. A later owner, Dr. Marion Michael Null, wrote a book called *Forgotten Pioneer: The Life of Davy Crockett* in 1954. (Published in the *Los Angeles Herald Sunday Magazine*.)

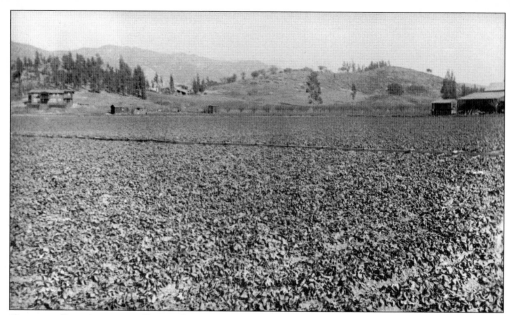

CHINESE CREWS AT THE GATES STRAWBERRY RANCH. The fields shown above were between Chickasaw Avenue and Yosemite Drive, Eagle Rock Boulevard, and the hills in the distance where Maywood Avenue is now. On the left is Gates Hall; farm sheds are on the right. Chinese crews came by wagon to the ranch from Los Angeles early in the morning to work the fruit. Then, as now, strawberries were a labor-intensive crop. (Above, courtesy Elena Frackelton Murdock family.)

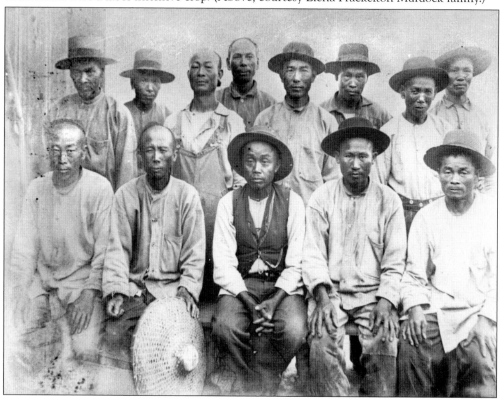

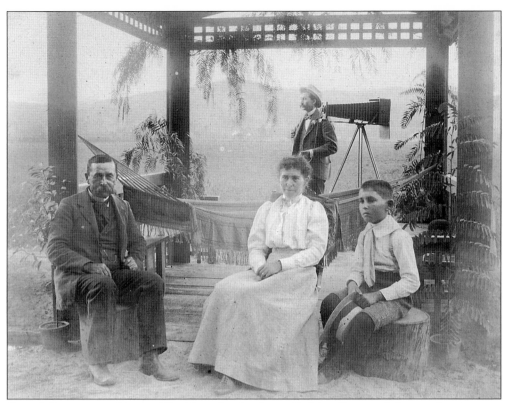

GATES'S STRAWBERRY RANCH. The Gates family—James K., Mrs. Gates, and their son Louis—pose for a photograph in their gazebo on the ranch, with another photographer in the background. Gates Hall, built around 1900, became the social center of the valley. Dances were held and attended by almost everyone. The music was provided by a player piano that everyone took turns pumping. Folks returned home across the fields by lamp or moonlight. Fred Eckert, the foreman on the ranch, built the house (below) that still stands on Yosemite Drive in 1911. Fred and Edith are on the porch. It was popular as it had the only telephone for miles around. The Eckerts were also one of the first to install electric lighting. Edith was a founder of the Friendly Club, which became the Women's Twentieth Century Club. (Above, courtesy Elena Frackelton Murdock family; below, Fred Eckert.)

SHAKESPEARE CLUB MEETING AT MAHLON MYERS'S. The objects of respectable late-19th-century, middle-class life surround, from left to right, Mmes. Broxholme, Katherine Frackelton, Myers, Knighttinger, and Ruth Parker. It is clear that these ladies took their role as bearers of culture seriously. The houses of the three Myers brothers, Emmet, Mahlon, and Byron, were south of Colorado Boulevard. Byron's house still stands at the lower end of Vincent Avenue. (Courtesy Elena Frackelton Murdock family.)

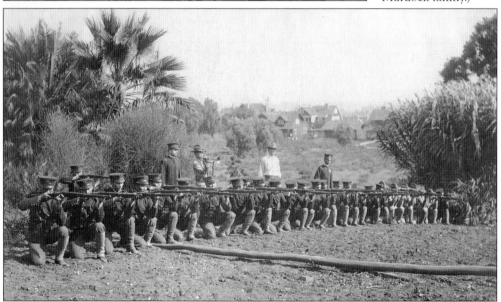

CHINESE TROOPS TRAINING C. 1906. Occidental College alumnus and military expert Homer Lea recruited Capt. Ansel O'Banion, in white, to train these Chinese immigrants to aid Dr. Sun Yat Sen in the overthrow of the Manchu dynasty. A photograph taken this same day was captioned, "Chinese troops training in Eagle Rock" in *Double Ten: Captain O' Banion's Story of the Chinese Revolution* by Carl Glick. The exact location of this training is unknown. (Courtesy Hoover Institution Archives, Stanford University.)

Two

FROM FARMLAND
TO HOMELAND

PRIME HOME SITES. As soon as the Los Angeles railway line was put through from Los Angeles, people who worked there could make their home in the new suburb. Farms and estates were subdivided rapidly. Godfrey Edwards and Otto J. Wildey were early investors. Edwards was an engineer, most prominently for the Los Angeles Coliseum. He took a personal interest in providing quality infrastructure in the communities he developed. (Published in the program for the Belasco Theatre, December 1909.)

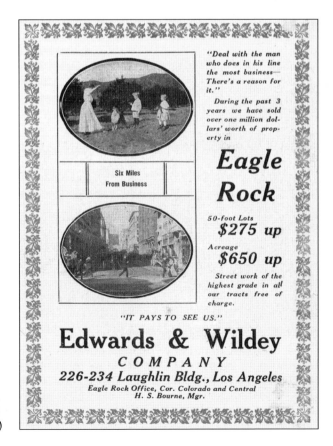

"Deal with the man who does in his line the most business—There's a reason for it."

During the past 3 years we have sold over one million dollars' worth of property in

Eagle Rock

Six Miles From Business

50-foot Lots
$275 up

Acreage
$650 up

Street work of the highest grade in all our tracts free of charge.

"IT PAYS TO SEE US."

Edwards & Wildey
COMPANY
226-234 Laughlin Bldg., Los Angeles
Eagle Rock Office, Cor. Colorado and Central
H. S. Bourne, Mgr.

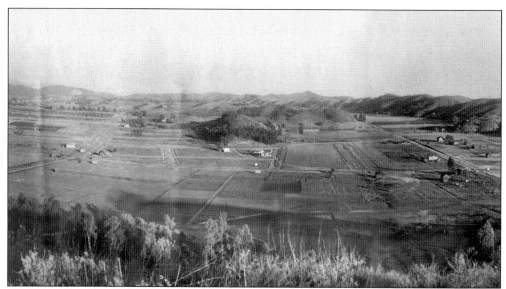

FROM 1908 TO 1923. Suburban development transformed the center of Eagle Rock. Pictured center left is the intersection of Colorado and Eagle Rock Boulevards. Colorado Boulevard runs up toward the Rock in the distance. Eagle Rock Boulevard, then Central Avenue, runs off to the left. Above, in 1906, is the old Congregational Church, the only building on Colorado, then Eagle Rock Road. The trolley tracks had been built, but traffic must have been light as a house, being moved, sits in the middle of the street. In the center, the Eagle Rock School is at its second location with the Gates Ranch to the left extending to Yosemite Drive, then Sycamore Avenue. Below, the Carnegie Library is at the far left with the Edwards and Wildey Building at the intersection. The Eagle Rock Central School faces the viewer with its end at Fair Park Avenue. (Above, photograph by C. C. Pierce.)

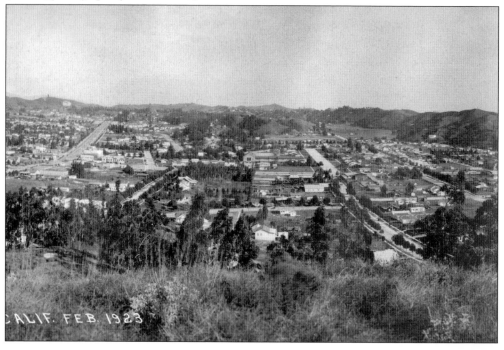

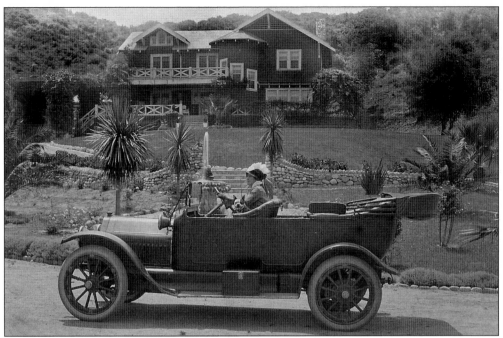

ALPHA FERDON AND HER HOME. James Ferdon made his fortune as a "Medicine Show" man and invested heavily in Eagle Rock's early development. A Mr. Rangaman, a lumberman, built the house in 1904. He personally selected the woods in the interior. In 1908, it was sold to Francis "Daddy" Silverwood, who owned a prominent regional menswear firm. He was also the author of "I Love You, California," the state song. (Courtesy Ricki De Kramer.)

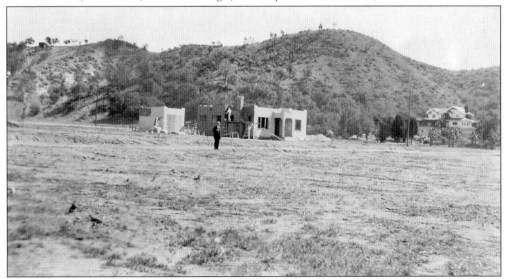

FIRST HOUSE IN HAPPYLAND. James Ferdon stands in front of the house under construction on Vincent Avenue. The house pictured at the top of the page can be seen in the background. The development was promoted as "Silverwood's Happyland," but Ferdon must have retained at least a sentimental interest, as this photograph comes from his family. This group of mostly small period revival houses is to the east of Eagle Rock High School. It was associated with a small commercial area at Townsend Avenue and Yosemite Drive. (Courtesy Ricki De Kramer.)

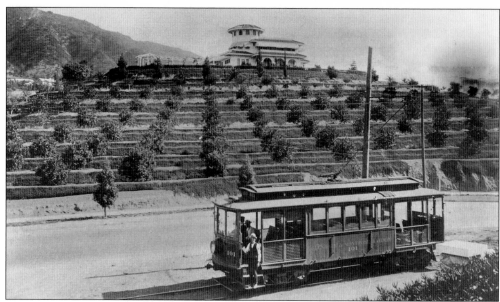

The Glendale and Montrose Railway Trolley. Here on the crest of the rise of Colorado Boulevard near College View Avenue, the railway, earlier the Glendale and Eagle Rock Railway, provided service to Glendale. William "Pop" Nagle was the motorman. Before Eagle Rock High School was built, students rode this trolley to Union High School near Brand Boulevard. The Bessolo house, built in 1910, stands on the terraced rise. The earliest meetings of St. Dominic's Catholic Church were held here.

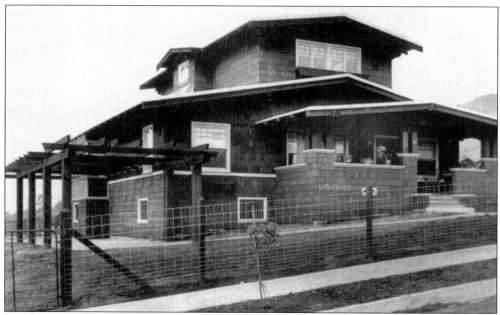

Hanson Puthuff House. Puthuff built this house in 1912 on the center of the three lots he had purchased on College View Avenue. It was designed and constructed by the New York Building Company. It was declared a Los Angeles Historical Cultural Monument in 2000. Puthuff was a pioneer of California plein air painting. Painted outdoors on the location depicted, the style emphasized free brushwork and the play of light on the subject.

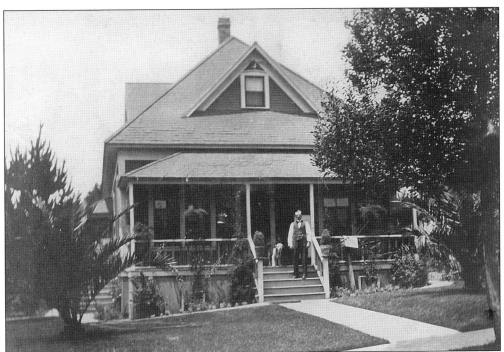

KARGER HOUSE. Johann Karger is on the front porch. He and his wife, Theresia, came here in 1905 and purchased the house. It was built as a farmhouse in 1895 and moved to the present location on El Rio Avenue. The house was stuccoed and re-windowed in 2004. Fred Karger, his son, immigrated here in 1903, at age 14, from Deutsch Liebau, in Austria, via Galveston, Texas. In the photograph below, he stands with his dog, his Maxwell, and his gun beside the house. (Both courtesy Doris Karger Thielen and Elmer Lorenz.)

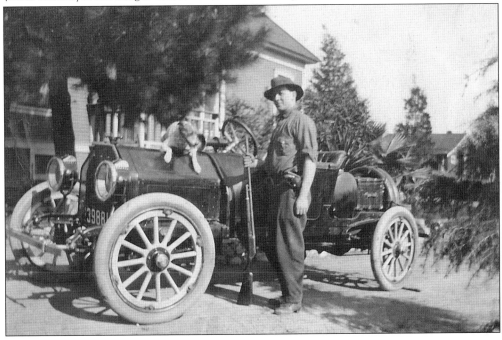

HELEN PRATT'S HOUSE AND YARDS. Pratt was a bird expert and Audubon Society stalwart. Her house on Ridgeview Avenue is shown above when new, with her on the lawn. She had originally named the street Ridgeway after a pioneering outdoorsman whom she admired. Pratt was an early environmentalist who planted her backyard with native plant species to attract birds. The children, much to her dismay, called her the "Bird Lady." Many children benefited from Pratt's teaching about the natural world. Two children are shown below with their toys in the garden behind Helen Pratt's house around 1915. Their identities are unknown, but the quality of the toys and their expressions suggest a comfortable place in the world.

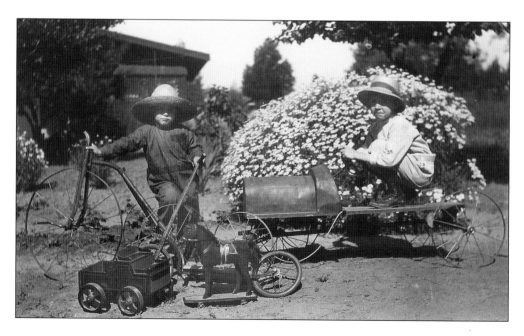

THE VALLEY'S FIRST GUESTHOUSE. The Villa Crowder was located against the southern hills behind the current location of the high school. It was probably built around the end of the 19th century in the Spanish Colonial Revival style. (Courtesy Elena Frackelton Murdock family.)

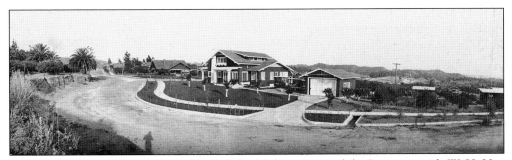

ORLANDO J. ROOT HOUSE. Root founded the Moline Automobile Company with W. H. Van Dervoort in East Moline, Illinois, in 1904. In partial retirement, he moved to Eagle Rock and hired Godfrey Edwards to build this house on Hill Drive in 1912. He was the founding president of the chamber of commerce, on the board of the Eagle Rock Bank, and chief fund-raiser for the Women's Twentieth Century Club clubhouse. A Moline car powered the 1914 Eagle Rock entry in the Rose Parade. (Courtesy Milton Lowrey.)

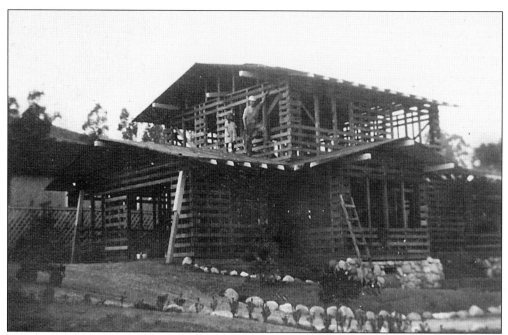

UP ON THE ROOF. William C. Phinney and his daughter Winifred stand on the roof of their partially completed house on Fair Park Avenue. The outer battens are in place for the shingle outer walls. Phinney constructed the house himself. He was a realtor, subdivider, and developer of many houses in the area. His office was on Colorado Boulevard. (Courtesy Harold and Deane Phinney.)

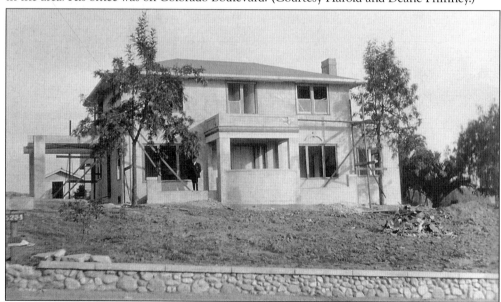

CHARLES E. HARSH ON HIS NEW PORCH. This house replaced P. W. Parker's house on Dahlia Drive in 1923. Harsh raised his family of four in the house. His son J. Richard Harsh in turn raised a family of six. He wrote a delightful memoir of his youth and his neighbor to the west, J. J. Broomall. With her children all attending Dahlia Heights, J. Richard's wife, Barbara Noble Harsh, became the backbone of the school's PTA. She was a founder of the Eagle Rock High School Alumni Association. (Courtesy Harsh family.)

WITH THE ROCK AT HIS BACK. After returning from wartime service in the U.S. Marines, John Luther constructed his family home on Kipling Avenue on weekends. He was an aerospace engineer with no background in construction, but being a practical man he studied and taught himself to build his Modernist-influenced house. He raised his family, served his community as a Scoutmaster, and remained an innovator and teacher in vehicle design. (Courtesy Luther family.)

OAKLEY L. NORTON DIGS DEEP. From 1960 through 1980, Norton designed and built innovative houses on Escarpa Drive. Each house had its own unique style. The house shown was truly his crowning achievement. The main construction was of slumpstone and concrete block to achieve the thermal mass needed for passive solar design. Redwood was used for architectural details as in his earlier designs. He was a philosophy major at Occidental and a founder of the Summer Drama Festival. (Courtesy Norton family.)

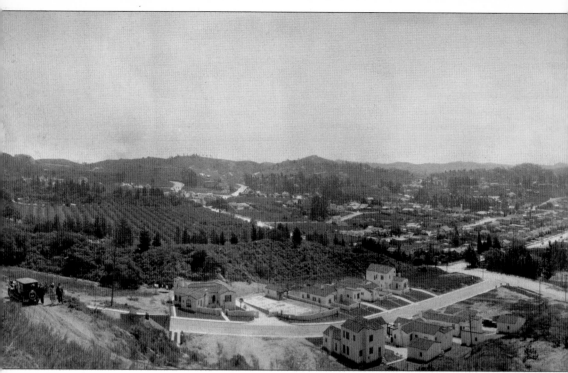

PANORAMA BY A. H. VARBLE, 1927. Looking down upon a looping Hill Drive, at the left is Stimpson's Lemon Ranch, the last farmland to be developed. The lemon grove was subdivided in 1949, and each owner built his own house. The top of this development was sheared off by the 134 Freeway in 1970. In the center stands the largest house ever built in the area. Martin Bekins, the founder of Bekins Van Lines, built it after he sold the company to his children. After his death in 1933, his wife, Kathryn Cole Bekins, sold the house to Wilfred "Bill" Lane. Lane had

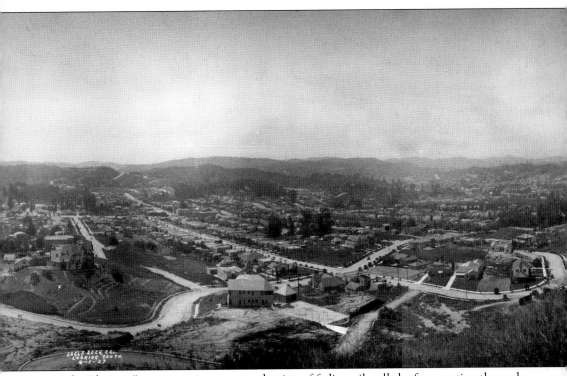

invented a "shotgun" process to improve production of fading oil wells by fragmenting the rock they penetrated. Many Scouts remember fondly the camp that he donated and supported in Big Tujunga Canyon. Lane's widow, Hazel Lane, sold the house to the current owner's parents. It has recently undergone a beautiful renovation. In the foreground and left of the photograph are large Mediterranean revival houses, which were being built at the end of the 1920s boom.

DUFFY HOME. The Duffys purchased this Spanish/Mission-style residence, built in 1922 on Hill Drive, after becoming one of the most influential couples in Eagle Rock. The son of a blacksmith, Duffy once told a banker who dismissed him that he would own the Edwards and Wildey Building. He later purchased and renamed the building. His vivacious wife, Eleanor, became a ubiquitous presence at town gatherings. She taught dance and ran a nightclub and was a force in the politics of the area. (Courtesy of the Security Pacific Collection, Los Angeles Public Library.)

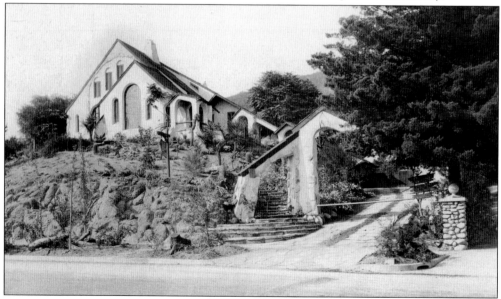

MA CASTLE. Albert Braisch was a successful heating manufacturer. He and his wife, Constance, were able to indulge their fascination with German culture by building this and several other houses on a large property on Hill Drive in fantasy style. The interior details and a large stained-glass window carry through this theme. Constance is remembered by many as the neighborhood piano teacher. (Courtesy Security Pacific Collection, Los Angeles Public Library.)

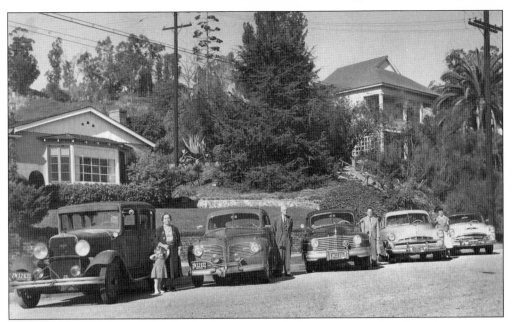

ROGERS FAMILY, AUTOS. Eagle Rockers' romance with their cars started early and grew strong. This photograph, taken on College View Avenue just up the street from the family home on Las Colinas Avenue, shows three generations. From left to right are a 1927 Chevy, Marie Lynn Rogers, and Carrie Rogers; a 1936 Plymouth and Loftus Rogers; a 1940 Ford and Harold Rogers; a 1951 Plymouth and Ruth and Karen Rogers; and a 1951 Chevy. (Courtesy Ruth Rogers.)

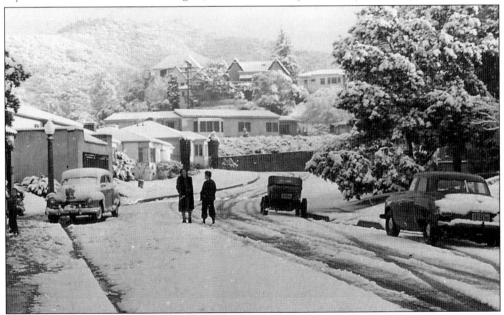

IT'S SNOWING! On January 10, 1949, the only lasting snowfall in memory occurred in Eagle Rock. This view from in front of the Allen home on Candace Place is reminiscent of a traditional Christmas card. Betraying the local origin of the photograph is the hot rod roadster in the center. Note also the background hills as yet untouched by the reservoir and freeway that would be constructed later. (Courtesy Allen family.)

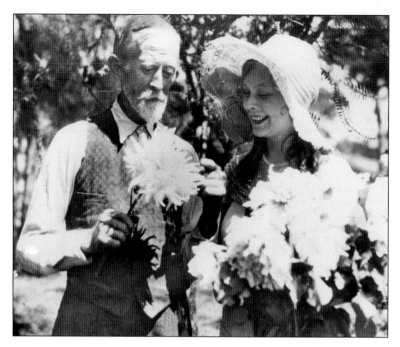

DAHLIA KING AND FRIEND. Jesse James Broomall raised and bred dahlias on his property in the valley west of Dahlia Drive until his death in 1937. He was known nationally for his horticultural efforts, published many catalogs, and wrote a column on gardening in the *Eagle Rock Sentinel* for many years. Dahlia Heights School and the street were renamed to reflect this famous ranch.

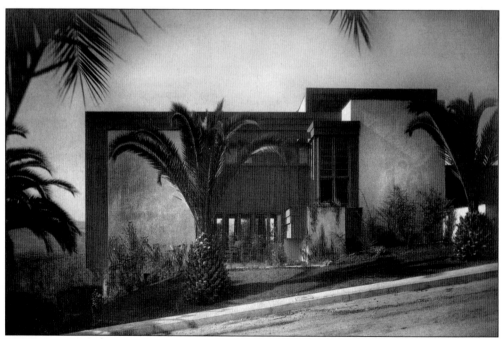

MODERNIST MASTERPIECE DEMOLISHED. Rudolph M. Schindler built this house for the Lowes family at 5325 Ellenwood Drive in 1923, a remarkable contrast to the other houses on the street. Drawings exist by Frank Lloyd Wright for the project, but Schindler designed this house in his own style. The upper end of this street was destroyed in 1969 for the 134 Freeway. (Photograph by Viroque Baker, courtesy University of California Santa Barbara Art Museum.)

Three

LOOK UP, LIFT UP

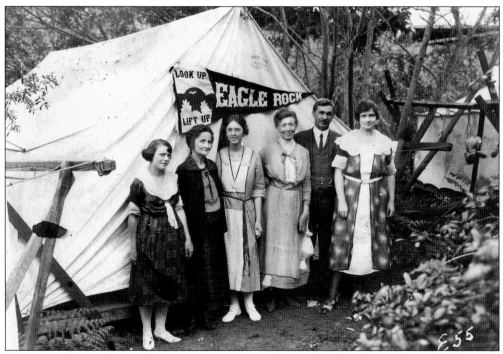

LIFTING UP EAGLE ROCK. This photograph, from a Methodist Church revival in 1923, shows a continuing effort at civic and moral improvement. The participants are, from left to right, Ursula Meadows, ? Sanders, unidentified, the minister and his wife, and Irene Miller. Organizations and individuals who worked for the betterment of the community on a local level and in a wider context have always characterized Eagle Rock.

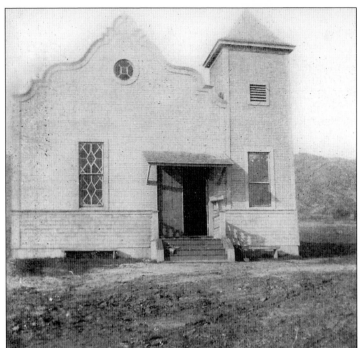

FIRST CHURCH BUILDING. In 1894, Ruth Parker started a Sunday school in her home. By 1896, services were held in the new schoolhouse. The church was chartered in 1897 as the First Church of Christ, Congregational. By 1898, plans were made to build a mission-style clapboard church. With gifts of labor and money, the "Little Brown Church in the Vale" near Castle Avenue and Eagle Rock Road (now Caspar Avenue and Colorado Boulevard) was built. (Courtesy Elena Frackelton Murdock family.)

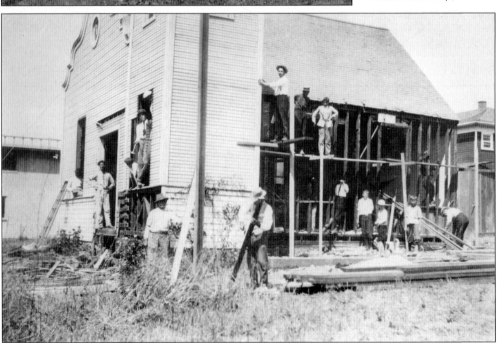

REMODELING OLD CHURCH. In 1907, the Reverend J. M. Spangler returned from missionary work in South America, moved to Eagle Rock, rented a hall, and began divine services under the name Eagle Rock Mission of the Methodist Episcopal Church. By that time, the original congregation had outgrown the little church and built a new church across the street. Spangler purchased the vacant Congregational church building for $1,300. It was remodeled in the fashionable Craftsman style for the Methodist church congregation.

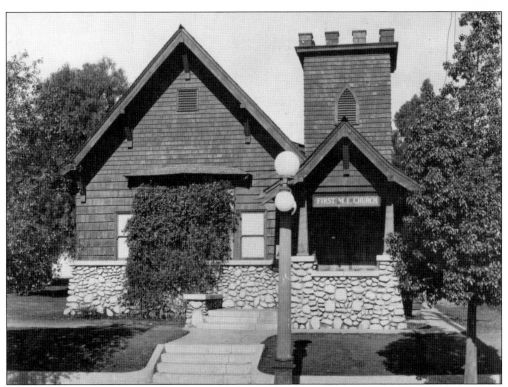

FIRST M. E. CHURCH REMODELED. Around 1925, it stands on Colorado Boulevard, which has added streetlights and trees. The congregation had purchased the Reynolds and Eberly Funeral Home behind it on Caspar Avenue to serve as a parsonage and Sunday school. They later purchased the two properties on Colorado Boulevard, east of Hermosa Avenue, for expansion. The Depression changed their plans, and they federated with the Congregationalists to form the United Church. This old church was torn down in 1949.

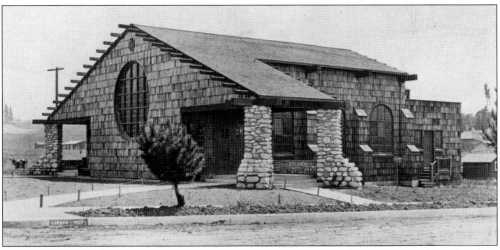

CONGREGATIONAL CHURCH OF THE GOOD SHEPHERD. Known generally as the Bungalow Church, it was built by Rev. Alfred Hare and his congregation at Maywood Avenue and Colorado Boulevard in 1909. It served until 1924. The building was then moved, first to Yosemite for an evangelical church, and then it became the frame for the Foursquare Church on Colorado Boulevard.

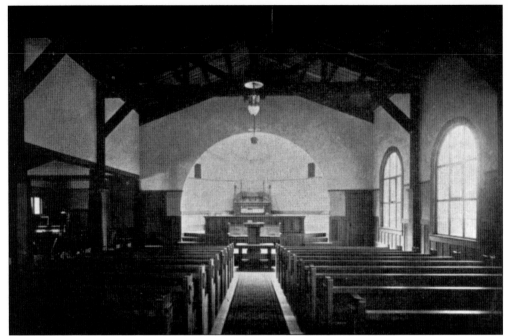

INTERIOR, CHURCH OF THE GOOD SHEPHERD. Here, in 1911, the interior is plain in keeping with Protestant tradition. It shows an unadorned pulpit and what appears to be an organ or organ pipes along the back wall. Rows of pews are on either side, and two large arched windows can be seen along the right side. (Courtesy the Security Pacific Collection, Los Angeles Public Library.)

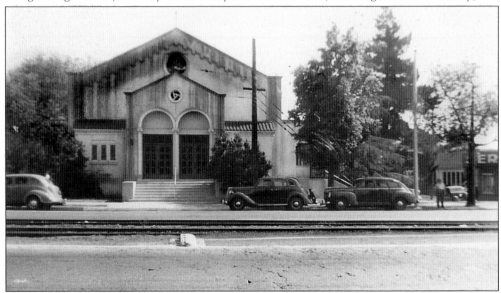

UNITED CHURCH. An expanding congregation required more room, and in 1924 this church was built in the revivalist style for the Congregational church. After the federation, it became the United Church and remained for years the largest Protestant denomination in Eagle Rock. An aging and dwindling congregation finally required a change. A growing Filipino population needed a church, so the building now houses the Los Angeles Filipino–American United Church of Christ.

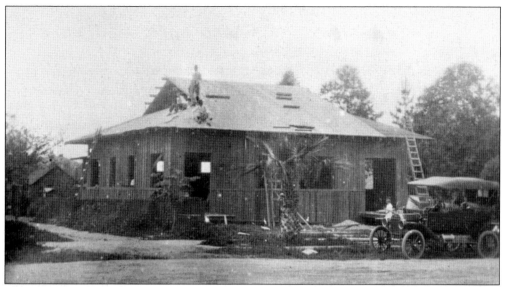

VOLUNTEERS BUILDING FIRST PRESBYTERIAN CHURCH. The first Presbyterian church congregation was established on March 5, 1914. Dr. T. T. Creswell served as pastor from April 1915 to September 1917. During his pastorate, this frame building was completed and the first meeting was held on Easter Sunday, April 4, 1915. The building later became Creswell Hall, was moved, and eventually succumbed to demolition in 1962 or 1963. (Courtesy the Security Pacific Collection, Los Angeles Public Library.)

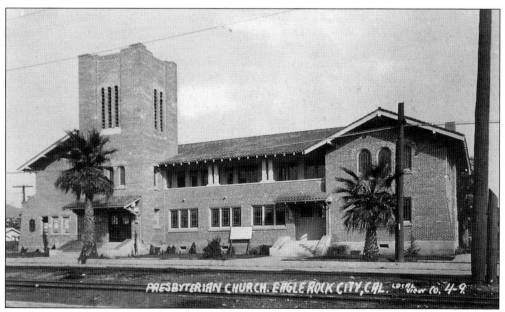

ENGLISH ROMANESQUE EAGLE ROCK PRESBYTERIAN CHURCH. Rev. B. B. Wetherall, who was called in 1918, carried out the plan to erect this sanctuary and west wing. The church is shown shortly after the time of its dedication, Easter Sunday, April 18, 1920. H. M. Patterson was the architect. This beautiful building was of unreinforced masonry. It was heavily damaged in the 1972 earthquake and later torn down. Modern buildings around a corner court have replaced it. (Published by the Local View Company, courtesy Stargel Collection.)

OLD LUTHERAN CHURCH. This small church at Maywood Avenue and Chickasaw Avenue was dedicated on July 10, 1927; the parish hall, to the right, was built in 1929. The church was enlarged in 1941. It served a mostly ethnic German population, which came with the growth of the 1920s. The next generation made this church too small for the congregation. (Courtesy Dave Schmidt.)

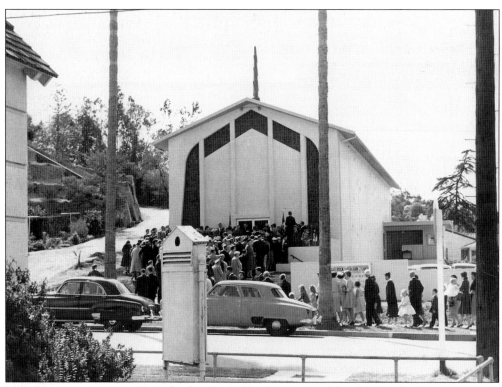

NEW LUTHERAN CHURCH DEDICATION. Framed by the corner of the old church, the congregation can be seen on the steps of the new modern church. Plans for the church began after a vote of the congregation in 1958. After many delays, the new building, designed by architect Walter R. Hagedohm, A.I.A., was dedicated on March 11, 1962. Unfortunately this expansion was followed by the dispersal of the younger generation. The facility now serves a small congregation, a preschool, and another small church. (Courtesy Dave Schmidt.)

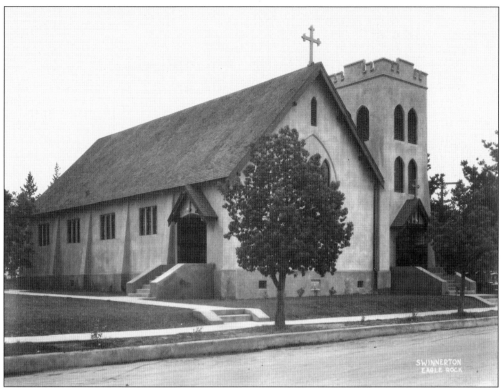

St. Barnabas Episcopal Church. This church was built in 1924 at the corner of Chickasaw and Caspar Avenues, replacing an earlier frame church. Architect William T. Major, an active communicant of the parish, designed the church. The Reverend Robert J. Renison founded the mission and, with the congregation, raised all the funds for its development. It became a parish in 1926 under his son, the Reverend George E. Renison. Many windows by Judson Studios of Highland Park embellish the church. (Photograph by Swinnerton.)

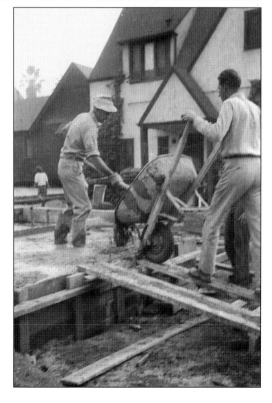

Construction, Parish Hall, St. Barnabas Church. The men and boys of the parish mix and lay the cement for the new two-story parish hall in 1950. Pipes for radiant heating were laid under the floor slab. The parish raised all of the funds for the construction. The Reverend Samuel Huntting Sayre was rector at this time. (Scrapbook donated by Syble Lagerquist.)

St. Dominic's "Old Hall." Early services were held in 1920 in a rented storefront and at the home of Angelo Bessolo. Two lots were purchased on Merton Avenue, and a tent was erected for worship. Sent by the Dominican Fathers to assume responsibility for the parish, Fr. Francis Driscoll offered the first mass with his people on October 16, 1921. A few weeks later, this wooden chapel, later known as De Porres Hall, was under construction.

Combined Church-School Building. This building, along with a convent for Sisters, was completed in 1925. Fr. McMullen, O.P., had planned the building, but when he was reassigned, Fr. James A. Hunt, O.P., became the third pastor and constructed the building. The Dominican Sisters of San Rafael were invited to staff the school. The school opened with 110 pupils on September 8. The first class graduated the following June.

40

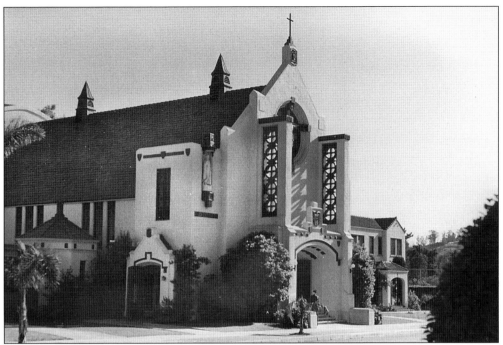

EXTERIOR/INTERIOR, ST. DOMINIC'S CURRENT CHURCH. The church opened on Rosary Sunday in 1941 on Merton Avenue across the street from the earlier buildings. The church and school have grown to occupy both sides of the street. "Over the years the complexion of the parish membership has changed greatly. St. Dominic's has been blessed with a rich cultural and religious heritage, and is indeed very 'catholic' in its membership. The reputation of the parish is very high due in great part to a visible spirituality among its members, the beauty of the church adorned so beautifully by its spiritual team, numerous well trained and spirited choirs, and many activities and outreach programs to enrich the spiritual and social life of the parish community," states a passage from *75th Anniversary History* that was donated by Fr. Anthony Patalano, O.P.

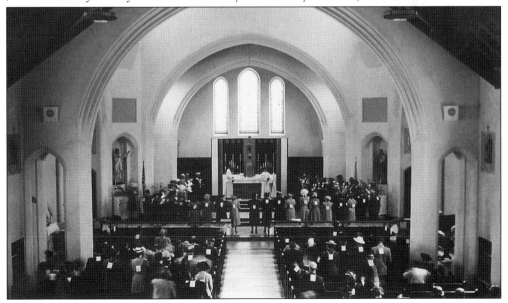

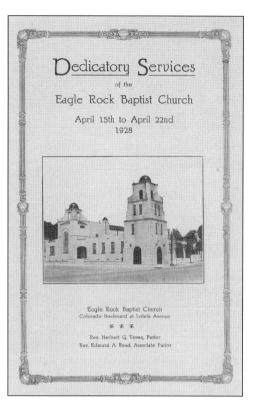

Dedicatory Services

of the

Eagle Rock Baptist Church

April 15th to April 22nd
1928

Eagle Rock Baptist Church
Colorado Boulevard at Loleta Avenue

⅌ ⅌ ⅌

Rev. Herbert G. Tovey, Pastor
Rev. Edward A. Read, Associate Pastor

EAGLE ROCK BAPTIST CHURCH DEDICATION.
This church, opened in 1928, has expanded
to fill most of the block on Colorado
Boulevard. The church hosted the Kiwanis
Scout house on its land until expansion
made this impossible. The current building
is in a modern style, but interestingly it was
a remodel of this building. Recently for its
75th anniversary, a mural of this church
and other local landmarks was painted on
the facade of the remodeled building.

**SUNDAY SCHOOL, COMMUNITY COVENANT
CHURCH.** Although this church occupies
a complex of fine buildings, it has always
emphasized ministering to the changing
spiritual and material needs of the community.
In the postwar years, a large number of
children needed a Sunday school, as in the
group shown here. The church also sponsored
a Youth for Christ Ministry in the 1960s and
today offers shelter and guidance to several
homeless families. (Courtesy Mickey Ferrell.)

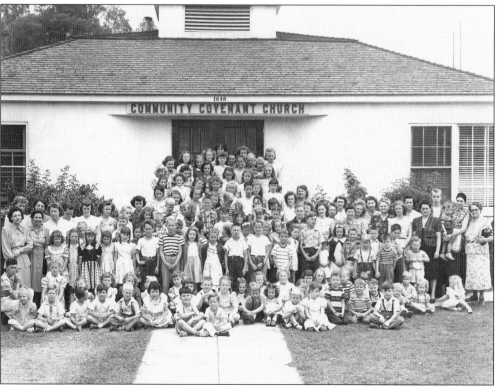

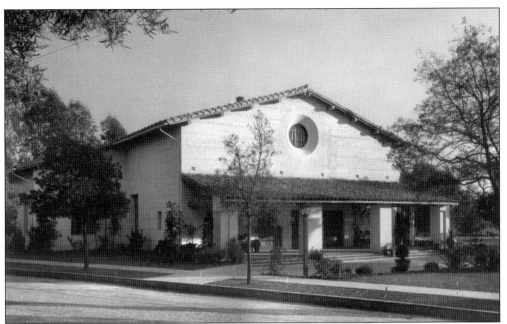

EAGLE ROCK SEVENTH-DAY ADVENTIST CHURCH. The building (here on February 15, 1929) was designed for the First Church of Christ, Scientist, Eagle Rock by architects Meyer and Holler. The congregation had dwindled to a few in 1983. To keep the building as a church, they sold it to the Adventists, who had, over the years, built three churches on Merton Avenue. They retrofitted this building for earthquakes and built a Family Center and additional parking. (Photograph by George D. Haight, courtesy Herald-Examiner Collection, Los Angeles Public Library.)

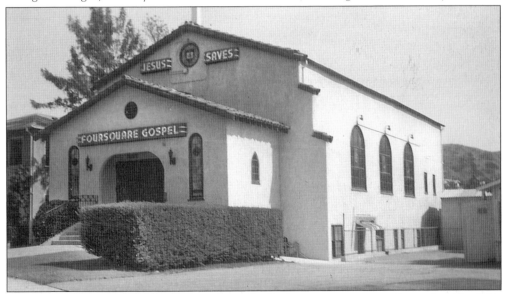

FOURSQUARE CHURCH. This building, where the Sizzler restaurant is now located, utilized the redwood frame of the bungalow church, which had previously been moved to the site of today's Covenant Church. The congregation of this church merged with the Italian Christian Assembly Church from Los Angeles. The combination grew larger and combined its resources to build the Christian Assembly Foursquare Church just east on Colorado Boulevard at Ellenwood Drive.

43

OCCIDENTAL PRESBYTERIAN CHURCH. Fire consumed this beautiful clapboard church on April 10, 1950. The church has always been closely associated with but not affiliated with Occidental College. The building was originally in Highland Park. It was moved in three sections to Eagle Rock and reopened on February 1, 1923. In 1938, a two-story education building was erected; this building was spared. A fund-raising campaign netted $52,000. Under the leadership of Rev. John Humphreys, a large fellowship hall and a small chapel were built to complete today's church.

WCTU HOME. The Eagle Rock Chapter of the Women's Christian Temperance Union, advocates of alcohol prohibition, was organized in 1886 by Mrs. Cash, the wife of Elijah Cash, Eagle Rock's first minister. Architect A. Godfrey Bailey constructed this building in 1927 as the Southern California Home for Aged Women. When this use declined, strong community efforts, principally by The Eagle Rock Association, led to the building becoming the headquarters of the Greater Los Angeles Agency on Deafness.

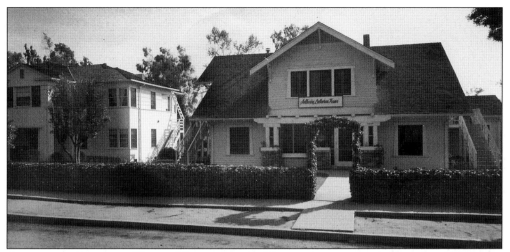

ANNEX AND CHAMBERS HOUSE. The property on Merton Avenue was purchased in 1923 by the Men's Brotherhood of Our Savior's Lutheran Church in Los Angeles. Adolph Larson Sr. led the effort, observing that the large majority of men died in poverty. The home was originally named Norwegian Lutheran Society for the Aged. By the time of its dedication on April 24, 1924, it had become the Solheim Lutheran Home. The annex on the left was added to the complex in June 1940. In recent years, the home has been completely rebuilt to modern standards and provides residence, assisted living, and skilled nursing care to seniors. Below, Leonard "Rocky" Rothbauer, a fine craftsman, resided at the home and had a workshop on the grounds. His cutout wooden world map in the dining room and a large freestanding model church still decorate the home. (Both courtesy Solheim Lutheran Home.)

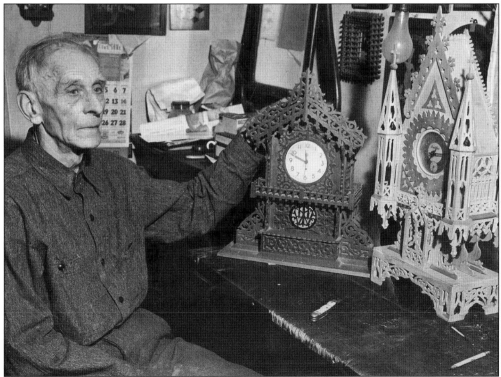

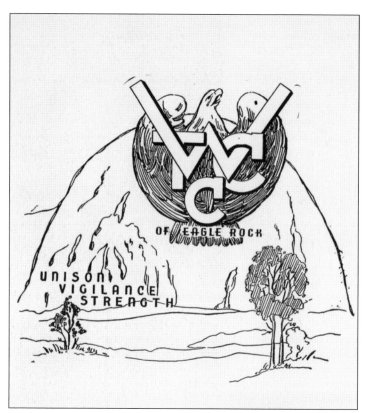

LOGO, WOMEN'S TWENTIETH CENTURY CLUB. The earliest social organization in Eagle Rock, outside of the church, aimed to improve the community and society at large. The club championed woman's suffrage, the arts, and the social graces. The ladies worked to support the troops in America's wars, cared for and educated young mothers during the Depression years, and contributed to saving the redwoods by purchasing a grove in what is now Redwood State Park. The club continues in this spirit into the 21st century. (Courtesy Women's Twentieth Century Club.)

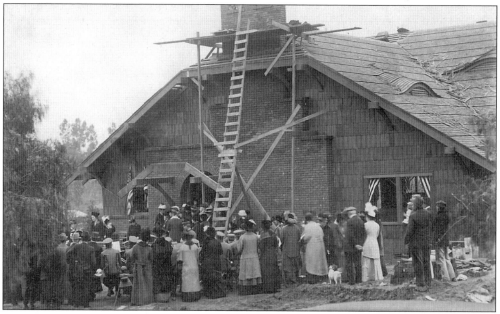

CORNERSTONE LAID, JANUARY 1915. Frank M. Tyler was the architect and Edwards and Wildey were the contractors for the clubhouse on Hermosa Avenue. In the end, $175 was needed to pay for the bricks. The ladies put on a successful fund-raising show with skits, and a song was written and performed by A. S. Bourne, the building supervisor.

AMBER AND EMMA YOUNG, 1906. Castle Crag, their home, was a center of art and culture. John Steinbeck is said to have written part of *Grapes of Wrath* in a rented room here. A former school principal, Mrs. Emma Young led the History and Landmarks Section of the Women's Twentieth Century Club for many years. Her death in 1961 prompted the founding of the Eagle Rock Valley Historical Society. Charles W. Young was a civic leader until diabetes forced his retirement and led to his early death. (Courtesy Louanna Clark.)

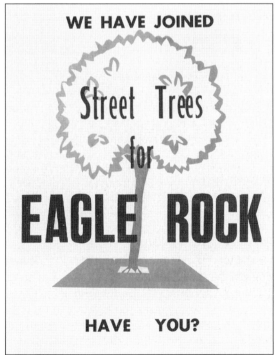

WE HAVE JOINED

Street Trees for

EAGLE ROCK

HAVE YOU?

STREET TREES POSTER. In 1963, 1964, and 1965, over 200 trees were planted on Colorado Boulevard, Eagle Rock Boulevard, and various smaller streets. Cochairwomen Mrs. Thomas E. Snow and Mrs. Robert (Doris) Thielen of the Women's Twentieth Century Club spearheaded the project. Scott Wilson was the chairman for Eagle Rock High School. The merchants, residents, and all of the civic organizations participated in the effort. Wilson later founded Northeast Trees, a leading tree-planting organization in northeast Los Angeles. (Courtesy Doris Thielen.)

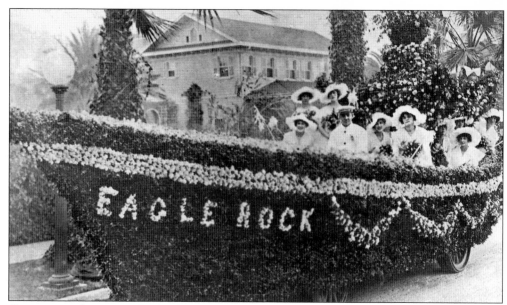

CHAMBER OF COMMERCE FLOAT, FIRST PRIZE, 1917. This was their fourth entry in the Pasadena Tournament of Roses Parade. The Eagle Rock Chamber of Commerce began in 1913 as the Goodfellows Club. They formed an organizing committee, with temporary chair Fred E. Biles, Sec. W. L. Miller, and members Godfrey Edwards, F. S. Hannaford, and Garner Curran. All joined the new chamber, and Orlando J. Root was elected the first president in 1914.

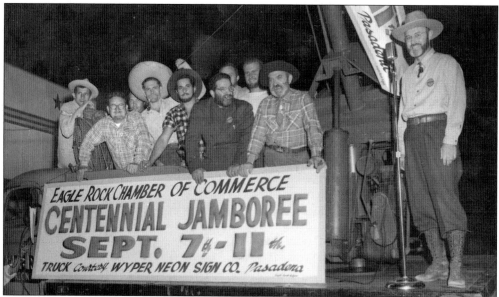

WHISKERINO CONTEST. In 1949, a re-chartered chamber of commerce celebrated the California State Centennial. In front, from left to right bearded D. Zakes, Jack McKay, Les Gifford, Ken Stein, H. Russell, Les Williamson, Leslie McGuire, and ringleader Carroll Evans (at the microphone) staged a mock lynching of rebellious beardless chamber president Harry Bolin (not pictured). The crane operator released the cable and dropped him. He suffered a broken ankle, head wound, and bruises. Bolin said earlier, "I wouldn't ask anyone to do this stunt. It is not dangerous but if anyone is hurt it will be me."

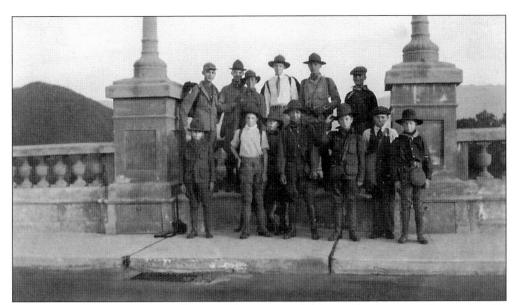

BOY SCOUTS, COLORADO STREET BRIDGE. These boys are hiking to Pasadena possibly to assist with the Rose Parade. The Scouts held a large camp out in the hills in 1910. Troop 1 was chartered in 1915, with Rollin McNitt as Scoutmaster and Fred J. Truman as assistant; there were two patrols. Up to 11 troops have been active in Eagle Rock over the years. (Courtesy Rollin McNitt.)

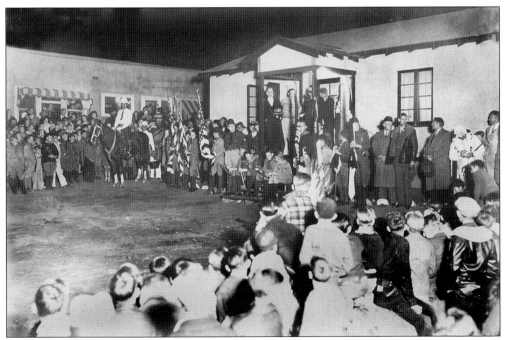

KIWANIS SCOUT HOUSE. A housing unit from the 1932 Olympic Village was moved behind the Baptist church. The dedication featured a personal appearance by Western star Tom Mix. The house was subsequently moved to Yosemite Drive to a donated plot. It housed youth groups until recently, when it was sold and modified into a residence. The Eagle Rock Kiwanis was chartered in 1923, sponsors the Eagle Rock High School Key Club, and emphasizes service to youth.

FIFTIETH ANNIVERSARY. The year 1961 marked the 50th anniversary of Eagle Rock's cityhood. The Lions Club is showing its patriotism in the parade near Eagle Rock and York Boulevards. Featured also is the club's longtime emphasis on the preservation of sight. The club financed a mobile unit in a school bus, as part of a national campaign to test for glaucoma, when this disease was a major cause of blindness in the United States. (Photograph by Joe Friezer.)

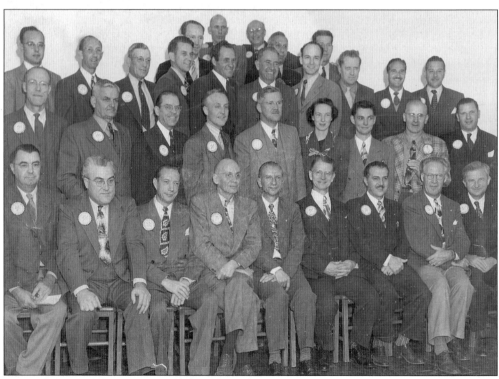

ROTARY CLUB OF NORTHEAST LOS ANGELES, 1947. This photograph, taken early in its existence, is typical of service clubs at that time. Now all of the clubs are open to women and much more informal. Rotary has always emphasized international work along with local charity, raising over $500 million in its campaign against polio. It has come close to wiping out the disease. (Courtesy Rotary Club of Northeast Los Angeles, Jack Stimson.)

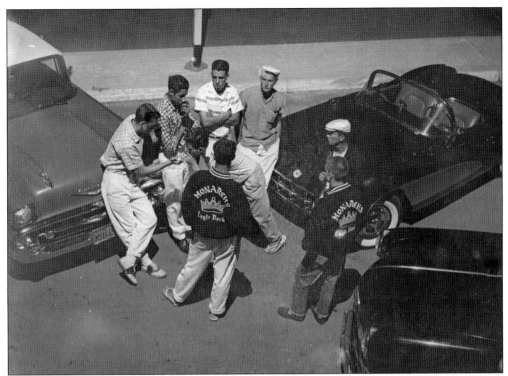

MONARCHS CAR CLUB. Hot-rodding and car clubs have a long history in the area. Many participants engage in charitable activities along with their enthusiasm for cars. The Monarchs were most active in the 1950s. The most prominent local clubs today are the Rockin' Rodders and the recently revived Trompers. (Courtesy Harry Chamberlain.)

EAGLE ROCK VALLEY HISTORICAL SOCIETY MUSEUM. Pres. Joe Northrup and founding members Katherine Gualano and Bernice Eastman Johnston are admiring the Rose Parade trophies. The museum opened in 1971 in the Eagle Rock City Hall (after the society and councilman Arthur Snyder saved it from demolition). The museum was displaced downstairs for council office expansion and put in storage during the earthquake retrofit of the building. The archive is now hosted by the Center for the Arts, Eagle Rock, in the refurbished old library building. (Photograph by Joe Friezer.)

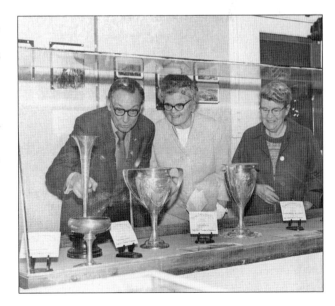

FIRST CELEBRITY. Madame Elsa von Grafé Menasco played at the opening of the Women's Club and many other early events. Her son was Ferdinand von Grofe, Americanized as Ferde Grofe, arranger and composer of the *Grand Canyon Suite*. Her brother Julius Bierlich was concertmaster of the Los Angeles Symphony. This trio occasionally played for private parties in the area. (Published in *Los Angeles Herald Sunday Magazine*.)

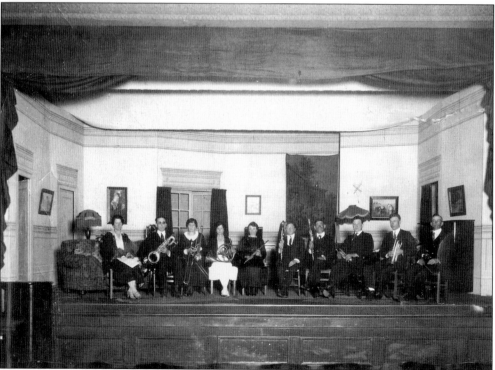

EAGLE ROCK SYMPHONY. One of many local musical and choral groups, the rather polyglot symphony plays here in the auditorium of Eagle Rock Central School around 1920. Fred Karger is the second from the right. (Courtesy Doris Karger Thielen.)

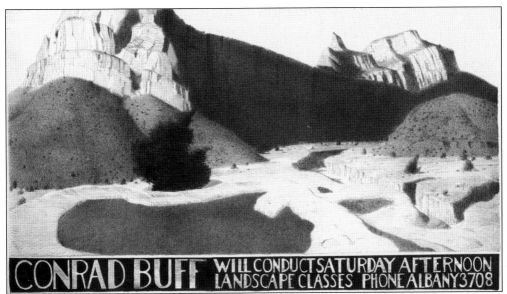

CONRAD BUFF WILL CONDUCT SATURDAY AFTERNOON LANDSCAPE CLASSES PHONE ALBANY 3708

PAINTING CLASSES. Conrad Buff II incorporates a view of the Southwest, typical of his work. While his paintings sell for large sums today, he made little on painting during his lifetime. He supported himself and his family as a sign painter and later as an illustrator of children's books with his wife, Mary. His son Conrad III, one of the great postwar Modernist architects, had his studio in their home for many years.

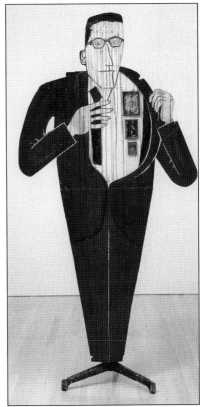

WALTER HOPPS HOPPS HOPPS. Walter, a pioneering curator of modern art, said of this sculpture, "A cartoon detective, Hopps, is depicted as a street con artist hawking tiny replicas of paintings by Pollock, Kline and De Kooning." He also said that Eagle Rock High School was "the most exciting time of my life; all of a sudden kids, boys, girls—friends." (Black and white front view of sculpture by Edward Kienholz, courtesy Nancy Reddin Kienholz.)

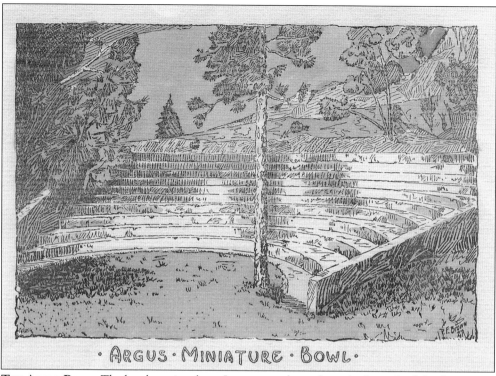

· ARGUS · MINIATURE · BOWL ·

THE ARGUS BOWL. The bowl was in a large Japanese-style garden, which was built by the owners previous to the Argus family. Performers included modern dance pioneers Ruth Saint Denis and Ted Shawn, who lived for a short time on Addison Way. Ironically, the lack of parking finally made the bowl impractical. This beautiful print (originally in color) by P. F. Brown was one of a series of handmade Christmas cards from the Argus family.

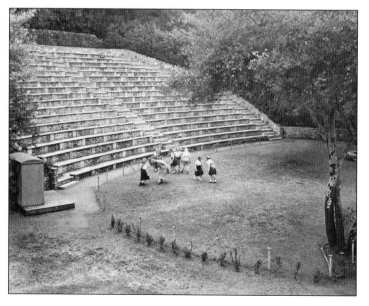

SYLVAN THEATER. Built as a WPA project of concrete rubble and other materials, Sylvan Theater was a beautiful addition to Yosemite Park. It served as a venue for summer theater programs and junior high graduations for many years. Revived from vandalism and disuse, it was programmed as a performance space by the Center for the Arts, Eagle Rock, and, most recently, for classic Greek drama by Eagle Rock High School.

Four

TO SCHOOLS

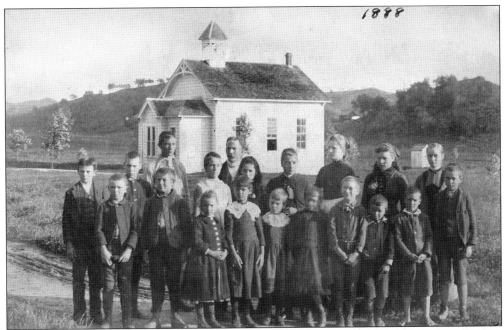

EAGLE ROCK'S FIRST SCHOOL, 1889. This school was built by community volunteers in 1886 near Colorado Boulevard just east of Caspar Avenue. The teacher, shown at rear, is Will Frackelton. The donor of this photograph, Elena Frackelton Murdock, is in the first row, fifth from the left. Lida Hutchins taught 17 pupils in 1884 in a barn on Addison Way that was owned by Milton Brown. The next year, Augusta Stevens moved the class to her own house. (Courtesy Elena Frackelton Murdock family.)

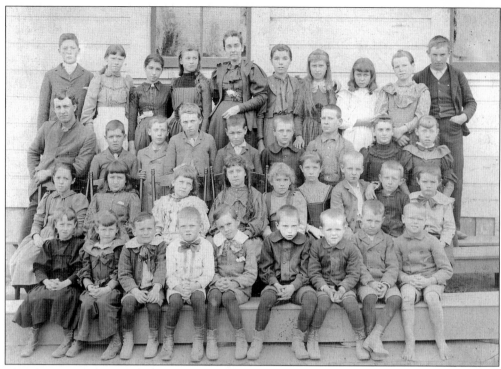

EAGLE ROCK'S STUDENTS, 1895. The teacher shown in the center of the back row is Myra King, who taught through most of the 1890s. Elena Frackelton is to the left of King. The trustees had added an open-sided lunch area to the building. The first flag to fly over Eagle Rock flew here, hand-sewn by Mrs. William (Alice) Frackelton. It was raised on Columbus Day 1892. (Photograph by C. C. Pierce, courtesy Elena Frackelton Murdock family.)

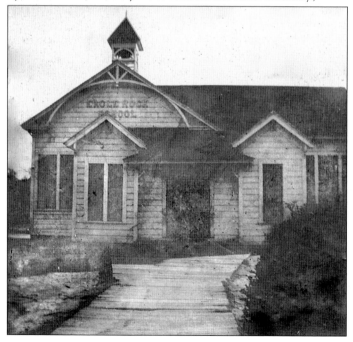

FIRST SCHOOLHOUSE RELOCATED. The school was moved northeast around 1905 to the foot of the hill where Chickasaw Avenue now meets Maywood Avenue. Two rooms were added to accommodate a growing student body. (Courtesy Elena Frackelton Murdock family.)

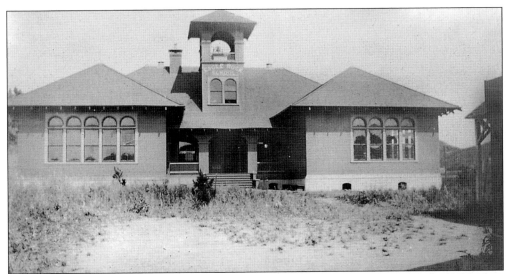

EAGLE ROCK'S SECOND SCHOOL, COMPLETED C. 1909. This new Craftsman-style brick building accommodated, for a few years, the rapidly growing population facilitated by the new trolley service and residential subdivision. At the right may be the old building prior to demolition. (Courtesy Elena Frackelton Murdock family.)

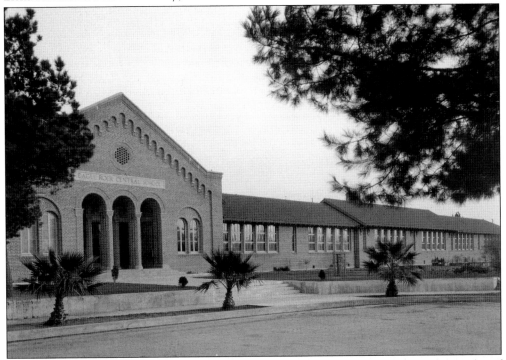

EAST FACADE OF EAGLE ROCK CENTRAL SCHOOL FACING CHICKASAW AVENUE. A larger plot of land, part of the Gates Strawberry Ranch, was purchased. This building, which still exists, was constructed in 1917 as a result of a long-sought compromise. A bond issue passed that financed this school and East and West Schools. The ends of the valley had developed, and parents did not want their children to make the long walk to the center. Godfrey Edwards was the contractor. (Courtesy Los Angeles Public Library, Security Pacific Collection.)

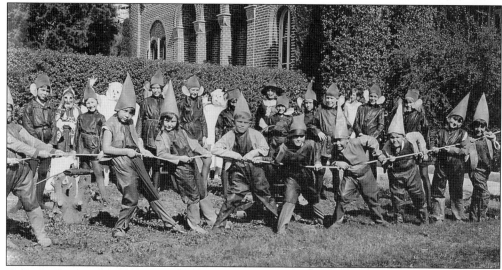

TUG-O-WAR, HARVEST HOME FESTIVAL. The unaltered facade of the auditorium can be seen behind the students, which dates the photograph before the 1933 earthquake. In the first row, third from the left, is Ricki De Kramer. John Swisher, fifth from the left, is tugging with the rest. Second from the right is Lucy Spurgeon. Second from left in the back row is Maxine (Mitchell) Tichenor, and next to her is Dorothy E. Swisher (in the mask), John's sister. (Courtesy John Swisher.)

SCHOOL'S SOUTH FACADE. Facing Fair Park Avenue, it was added around 1927, and it became the main entrance and remains so today. The sign over this entrance states, "Eagle Rock School," as all of the schools were now part of the Los Angeles School District and had non-directional names. The PTA planted the deodars during the presidency of Valley Knudsen, a beautification activist, who went on to found Los Angeles Beautiful. She and her husband, Thorkild (Tom) Knudsen, owned Knudsen's Dairies.

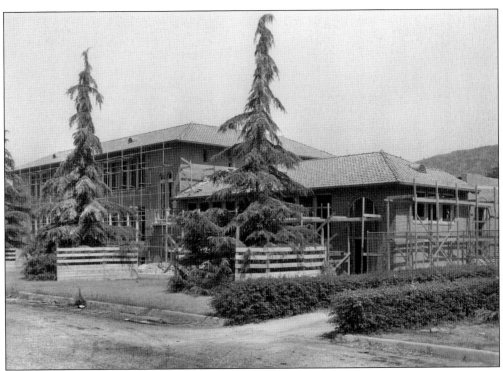

EARTHQUAKE REPAIRS. After the 1933 earthquake, classes were moved to the playground while damage was assessed. Although no significant damage was discovered in either masonry building, it was determined that reinforcement was necessary. A WPA grant was obtained for the massive district-wide rebuilding. Steel was added to the supporting structure, and the buildings were stuccoed to cover it. (Courtesy LAUSD Art and Artifact Collection.)

SAME FACADE, DIFFERENT ANGLE, 1965. The facade shows the changes made during the earthquake safety retrofit of 1934. The steel and original brick was covered with the stucco seen here. The original sign was preserved. This early retrofit preserved the handsome building, the only Eagle Rock school that was not torn down and replaced for earthquake safety.

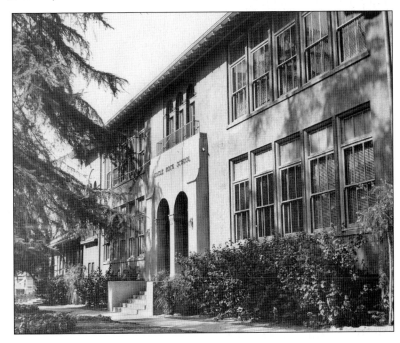

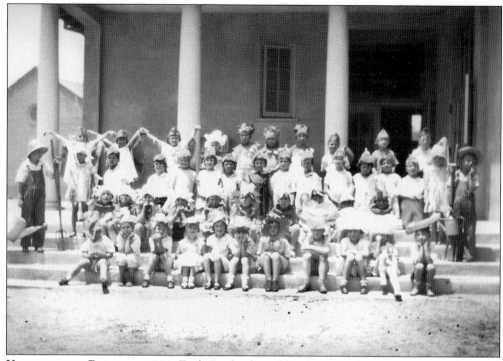

KINDERGARTEN BUILDING, 1929. Eagle Rock adopted kindergarten (a new concept at the time) in 1915. Miss Walker found 30 children under five and a half out of a population that had not reached 1,000. Anne Hare Harrison introduced the first Harvest Home Festival, commemorating Thanksgiving, in the fall of 1920. Put on by the PTA, it was a carnival occasion with food booths, games, and light and serious stage entertainment.

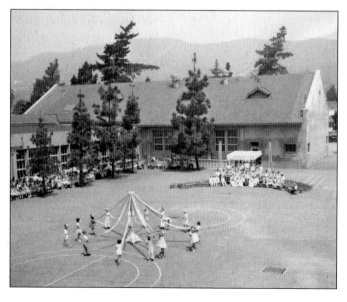

MAY FESTIVAL AFTER 1934. The rear of the 1917 building stands in the background, with the auditorium projecting to the right. The playground has been paved. The May Festival was the second of the two fund-raising community festivals sponsored by the PTA. In those days, when few women worked outside their homes, the PTA was the focus of many women's efforts. Often the organization had over 100 members and raised substantial funds to enhance the schools.

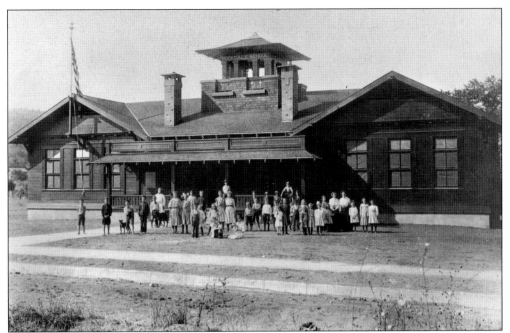

FIRST ROCKDALE SCHOOL, 1909. This was located by a pond and the stream that originated in the Eagle Rock Canyon and ran down Sycamore Avenue (Yosemite Drive). Sycamores flourished in this riparian area. Part of the Annandale School District, Rockdale was just outside the city of Eagle Rock. The area was annexed to Los Angeles and its school district in 1914. A sense of apartness in this "Yosemite Valley" persisted for many years.

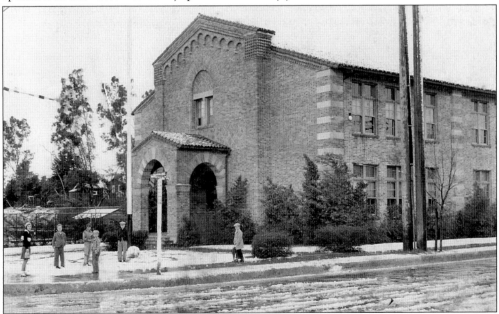

ROCKDALE'S FIRST MASONRY BUILDING. The snow was very unusual. This is probably soon after it was built in 1928. The flagpole is preserved at the present school building. The beautiful old masonry structure was torn down after the 1972 earthquake made its safety doubtful. (Photograph by Hegner, courtesy Rockdale School, Diane Jorgensen.)

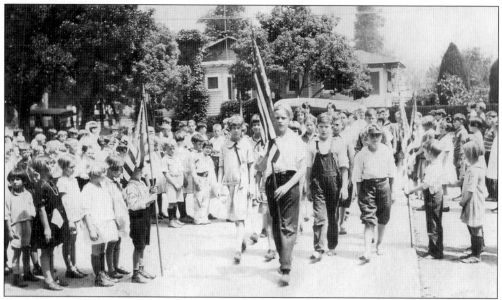

ROCKDALE SCHOOL MEMORIAL DAY CEREMONY, 1925. This event honoring America's veterans is the oldest tradition at the school, held the Friday before Memorial Day. After the masonry building was constructed, the ceremony was moved to the flagpole in front of the school, which still centers the event today. The kindergarten-auditorium building can be seen behind the students. Built in 1922, it served as the second two classrooms and a school and civic gathering place. (Photograph by Hegner, courtesy Rockdale School, Diane Jorgensen.)

WEST (SAN RAFAEL) SCHOOL STUDENTS, 1920. The school was built after the 1917 Eagle Rock District bond issue mandated regional schools. Classes were held in rented rooms while the building was being constructed. It was located near Broadway and El Verano Avenues, surrounded by open space. Elmer Lorenz is the third boy from the right in the second row. (Courtesy Elmer Lorenz.)

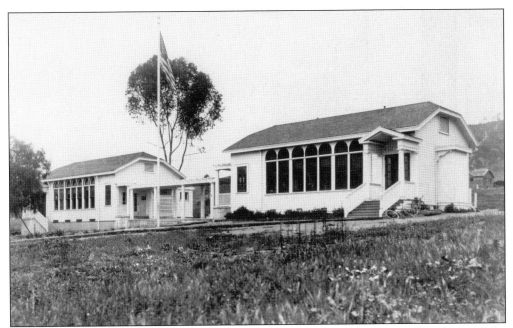

WEST (SAN RAFAEL) SCHOOL EXPANSION. The date and circumstances of this doubling of the school are unknown. The building to the left appears to be the addition. Possibly a bathroom with outdoor access has been added to the right. The location remains an open field of wild flowers. (Courtesy Security Pacific Collection, Los Angeles Public Library.)

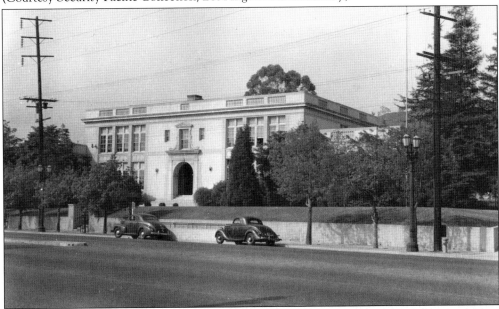

MASONRY SAN RAFAEL SCHOOL. The school stood on Broadway Avenue, shown here in the late 1940s. James Fleming speaks of restoring the garden, "We learned to pull weeds, level ground, clear rubbish, till soil, plant, fertilize and water . . . our grade-plots bloomed with lilies, roses, snapdragons, sweet peas and sunflowers. We grew cucumbers, carrots, corn, radishes, tomatoes and lettuce." The school was torn down in the late 1960s and abandoned to the coming Route 2 Freeway. (Courtesy James E. Fleming.)

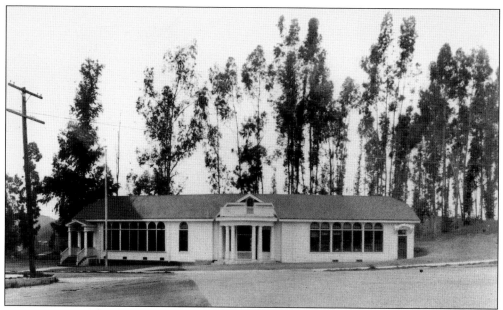

EAST SCHOOL (DAHLIA HEIGHTS). Another result of the 1917 bond, the building stood on the corner of Colorado Boulevard and Floristan Avenue. Classes were held in the Murfield Block at Townsend Avenue and Colorado Boulevard, and under a large tree in the rear, while this building was being constructed. It looks very similar to the West School and may have been built by the same contractor. The pillared portico and left-hand end of the building survived as a kindergarten until all the buildings were torn down. (Courtesy Security Pacific Collection, Los Angeles Public Library.)

DAHLIA HEIGHTS SCHOOL, 1934. This masonry school replaced part of the old clapboard building in the late 1920s. This building was on the corner of Floristan and Waldran Avenues, with an auditorium that had a porch at the left-hand end and stairs to Waldran Avenue.

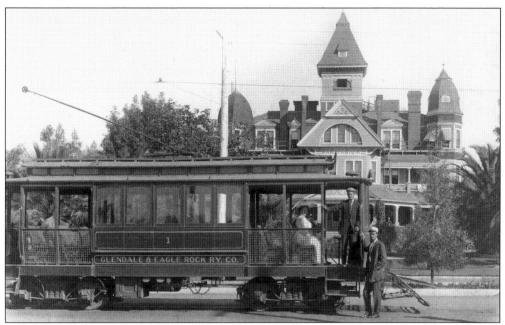

St. Hilda's, Earliest High School. Before Eagle Rock High School was built, students from Eagle Rock's schools went to this school, later the Glendale Sanitarium. It was located on Broadway Avenue in Glendale. In 1904, Union High School opened on Brand Boulevard. In 1908, a new building was constructed. The trip was made easier by the Glendale and Eagle Rock Railway, built by Eagle Rocker E. D. Goode in 1910. Ray Goode, his son, stands in the vestibule. (Courtesy Glendale Public Library Special Collections.)

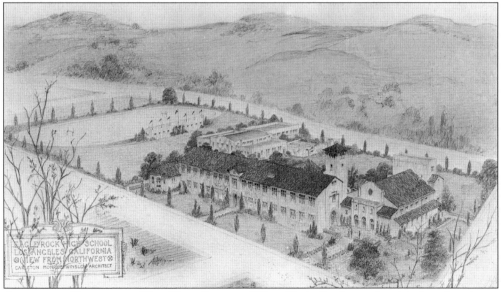

Architects Rendering, New High School. When Eagle Rock voted to join Los Angeles in 1924, the city offered several benefits: an assured water supply and a local high school. The school was competed in 1927. This rendering shows the gym and shops at the rear, the first classroom building with the library extending out at the left, and the auditorium at the right. (Courtesy LAUSD Art and Artifact Collection.)

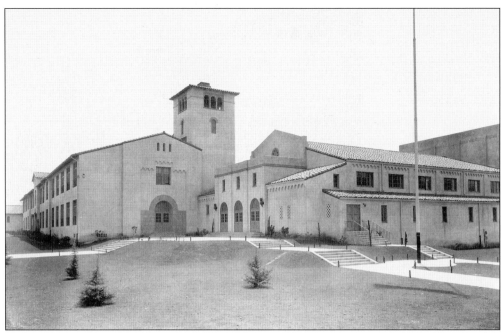

CLASSROOM AND AUDITORIUM FORECOURT. Generations of class plaques were placed here. At left center is the signature bell tower of this mission revival structure. To the left is the auditorium, which was incorporated into the new school that was built in 1970. The deodars on the lawn grew large and shaded generations of students on what was then called the Senior Lawn.

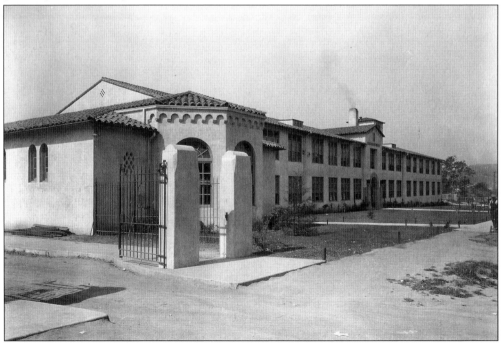

MAIN GATE AND LIBRARY. The wing of the library is on the left; just behind is its projecting bay. The classroom building runs into the distance with its emphasized central main entrance. In the distance is the tower, purely ornamental except for its utilitarian smokestack.

A9 Quad. In the rear of the original building, this courtyard was added, connecting the building and the side of the auditorium in the manner of an arcaded cloister. The gable on the left is of the junior high building, and the roof slope shelters the cafeteria. The ninth-grade class was given use of this area for lunch. (Courtesy LAUSD Art and Artifact Collection.)

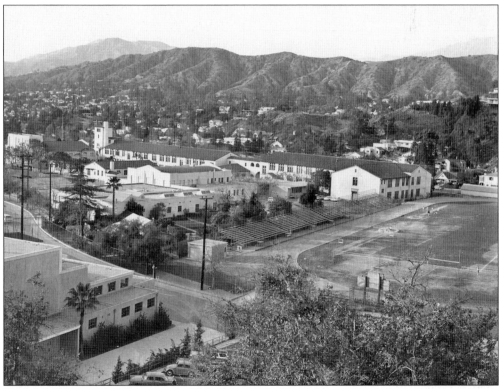

FROM THE HILL TO THE SOUTHEAST. The photograph shows almost the whole campus, as it was in the 1960s, with the football field in the foreground. The new boys' gym (large gym) is at the left. Behind it is the double row of shop buildings, with the girls' gym at its end. At left center is the L-shaped junior high building. The two main buildings were joined by a covered bridge, which is echoed in the new school. The hill from which this was taken adjoins Occidental College on the opposite slope.

WOODCUT OF THE TOWER. This work by Jean Brown was part of a suite of sectional dividers, signed and bound into the first school annual, the *Totem*, in 1929. The tower is central with two bays of the cloister at the left and the classroom building beginning at the right. The arts were essential to principal Helen Babson's concept of a progressive balanced education.

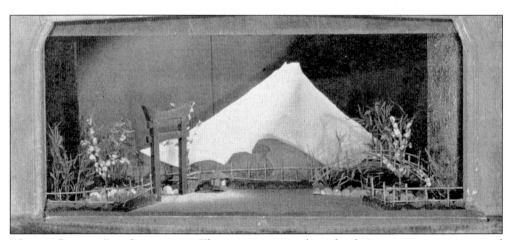

"CHERRY BLOSSOM" ON STAGE, 1930. This stage setting in the style of a Japanese print was pictured in the 1930 *Totem*. The interior of the auditorium is the only place on campus that remains as it was in 1927. The original stage machinery also remains. It will be replaced in 2010. (*Totem*.)

HELEN BABSON, 1930.
Babson was Eagle Rock High School's first principal, serving until 1945. Educated at Vassar, where she was a leading scholar and athlete, she had a progressive view of education that emphasized the harmony of the arts, academics, and athletics. The accomplishments of Eagle Rock's graduates in those years testify to her success, although some complained that they never learned to spell. (*Totem.*)

HOWARD SWAN AND BENJAMIN CULLEY (CENTRAL PAIR). Swan (on the left) began teaching social science at Eagle Rock in 1930. The next year, he switched to music and directed choirs until his departure for Occidental College in 1937. Benjamin Culley graduated in 1930, attended Occidental College, returned to teach math at Eagle Rock, and then went back to Occidental and taught math and became dean of men. Both earned their Ph.D. after leaving Eagle Rock. (*Totem,* 1934.)

EAGLE ROCK'S FIRST FEMALE CHEERLEADERS. Pearl Bloss Singer (left) and Virginia Strong Garth were the first female cheerleaders. Prior to the fall of 1938, Babson did not allow women to play this role. The male head cheerleader that year was Joe Morreale, a member of a prominent Italian American family. Joe later became a local doctor.

"TELLURIANS" (W'68) PLAQUE PLACEMENT. Each class, beginning in 1929, has its plaque in the auditorium forecourt. Today there are over 125 in place, designed by each senior class. The early plaques were crafted by the students in the school's shops. The alumni association cares for the plaques today, and since 1988, Michael Menegazzi, a leading terrazzo craftsman, has collaborated on and crafted each plaque. (*Totem,* 1968.)

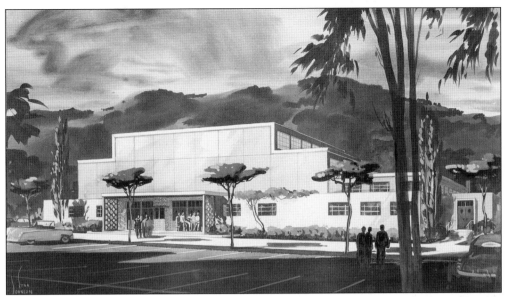

NEW BOYS' GYM. The first permanent modernist structure on the campus, built in the early 1960s, provided a clerestory-lit gym with folding bleachers, coaches' offices, a classroom, and locker rooms. At the same time, new parking lots were built and Oak Grove Avenue, which ran through the campus, was closed to provide additional space for a growing school. (Rendering by Stan Johnson, courtesy LAUSD Art and Artifact Collection; architect Louis A. Thomas.)

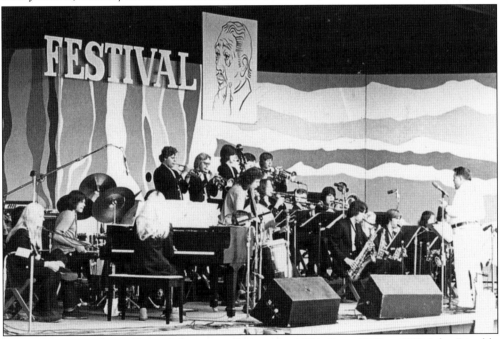

STATE CHAMPION STAGE BAND, MONTEREY, SEPTEMBER 1974. From 1968 to 1987, John Rinaldo was the driving force behind the unstoppable jazz-playing students coming out of Eagle Rock High School. He led the only band to make the finals at the Monterey Jazz Festival 16 years in a row. John was able to hone professionals out of his beginning students over a six-year period. He put Eagle Rock High's jazz program on the map nationally. (Photograph by N. W. Lund.)

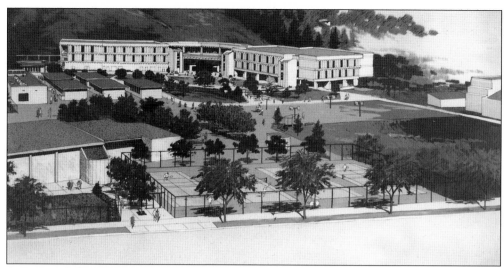

ARCHITECT'S RENDERING, NEW SCHOOL, 1970. The original Eagle Rock High School buildings, although restorable, were torn down for safety reasons. A new campus was designed in contemporary "brutalist" style and built to segue with the demolition. The new classroom buildings were nestled against the hills, with the grounds and smaller buildings forming a garden court in front. On the left is the new small gym. The corner of the auditorium is at left.

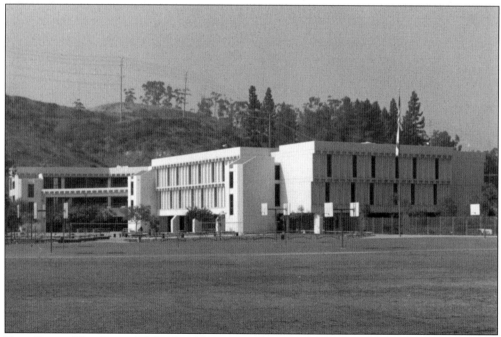

FIRST PHASE, NEW SCHOOL. Like the old, the new school was built in two stages. The first classroom and administrative office building are complete, here ending with stairwells on the left, which will begin the second classroom block. The sheltered courtyard in the center forms an eating area in front of the cafeteria. A second-story bridge, here unroofed, will connect the two buildings as a reflection of the old school. (Courtesy LAUSD Art and Artifact Collection.)

FIRST KEY CLUB CHARTERED, 1949. This Kiwanis-sponsored all-male service group lasted about 20 years. The charter is being presented by Emil Swanson (left) and Morris Campbell; the membership is unidentified. There were many service clubs at the school at the time, which had evolved over the years. The clubs, divided by sex and mostly self-selected, were reflective of the strong social hierarchy of the school.

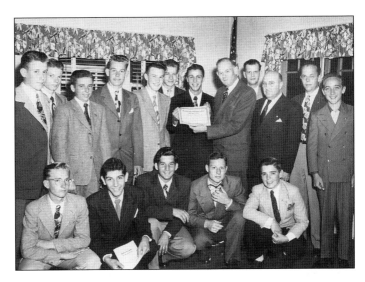

KEY CLUB SERVING AT THE HISTORICAL SOCIETY, 2007. At the Ice Cream Social from left to right are Nikki Ribas, unidentified (back to camera), Reynard Kibiling, Patrick ?, Keturah Klascius, Kristen Vavala, and Edgar Barrios. By the time the Key Club was rechartered in 1985, sex segregation and self-selected social clubs were no longer allowed. This opened the way for any student to participate. The Key Club is now one of the largest organizations on campus honored for serving the school and the community. (Photograph by Moran-Taylor family.)

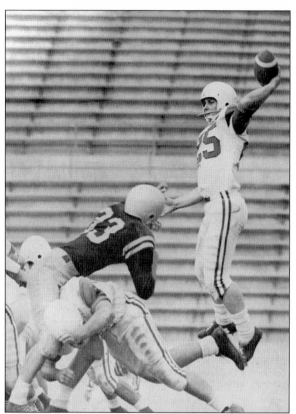

CITY CHAMPS IN ACTION, 1957. At right, All-City Quarterback Larry Ramsey passes for a touchdown. At left, Kenny Arndt blocks. Always a small school, Eagle Rock has produced many great athletes, among them Alumni Hall of Famers Tom Meyer (S '53) in track and Dean Balzarett (S '57) and Dave Brown (S '68) in track and football. In 1937, the unofficial city champion basketball team moved on together to Occidental, where they starred for four years. (*Totem*, 1958.)

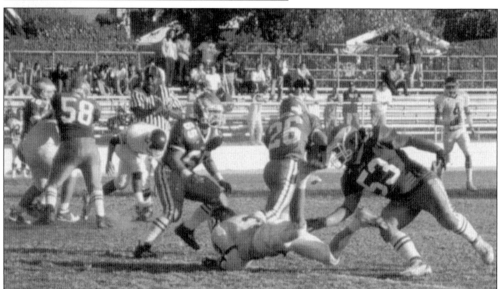

CITY INVITATIONAL CHAMPIONS, 2006. In a game against Bell High School, V. J. Castanos (26) breaks a tackle and heads for a touchdown. Blocking for him are Edwin Real (58), Jose Jaquez (65), and Jose Enriquez (53). This was their opening playoff win on the way to their second consecutive championship. Still the smallest school in the district, Eagle Rock remains an athletic power. In 2007–2008, these boys and girls won league championships in 10 out of 12 sports. (*Totem*, 2007.)

Five

OCCIDENTAL
MOVES NORTH

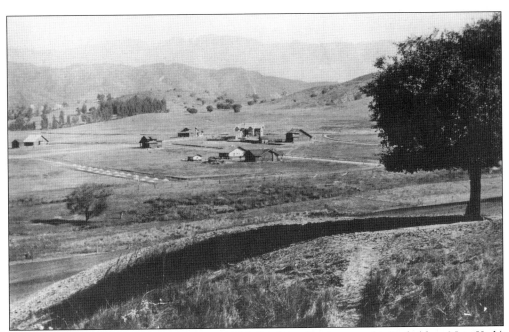

FUTURE SITE, OCCIDENTAL COLLEGE, C. 1900. Looking from across the York (then New York) Valley, the elevated flat area with the lollipop-shaped trees is the location of today's central quad. Ralph Rogers's house, later the Phi Gamma Delta house, is in the center. Rogers gave part of the 65 acres donated by local real estate men for the campus. A viewer here in 1887 would have seen the tracks for the Garvanza and Eagle Rock Railway, built by Rogers; the service lasted 10 days.

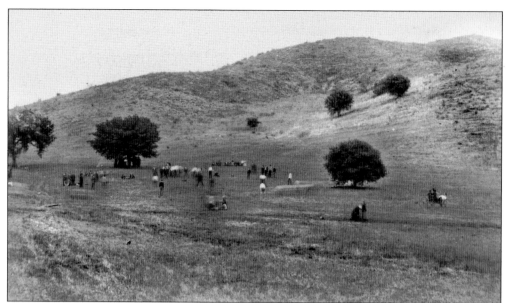

"Oxy" Students Visit from Highland Park. The college had moved there from Boyle Heights in 1898. The Highland Park campus, near Avenue 51 and Meridian Avenue, was problematic: it provided little room for expansion and was bisected by the Santa Fe Railroad main line heading east. College president John Willis Baer and the trustees decided to forgo the site's convenient transportation access and move to an open site near Eagle Rock. (Courtesy College Archives—Occidental College Library.)

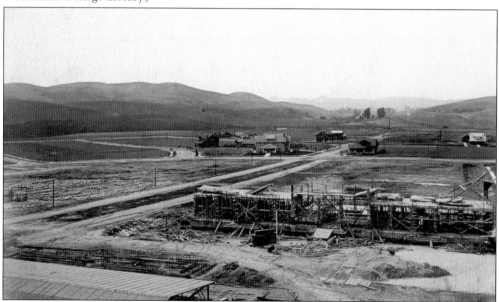

Skeleton of Swan Hall Dormitory. Alumni Avenue stretches to York Boulevard while Campus Road wraps around the campus. This view is from the hill where Orr Hall dormitory will be built and looking down the valley, which will become Glassell Park, to the Los Angeles River in the distance. Unseen to the right are Johnson and Fowler Halls. The area in the center, just over Ralph Rogers's house, is the location of an artesian spring, now tapped by Sparkletts Water Company. (Courtesy College Archives—Occidental College Library.)

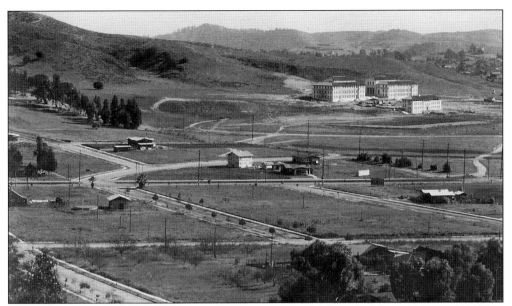

OCCIDENTAL COLLEGE FROM HILLS NORTHWEST. The first three buildings are completed but unoccupied in 1914. Eagle Rock Boulevard is the divided street running from left to right in the center of the photograph. The street layout is as it is today. Johnson and Fowler Halls, the paired buildings, contained classrooms and administration offices. Swan Hall, in front, was the first dormitory. This was unincorporated land located south of the city of Eagle Rock. (Postcard photograph by B. D. Jackson, courtesy Louise White Puthuff.)

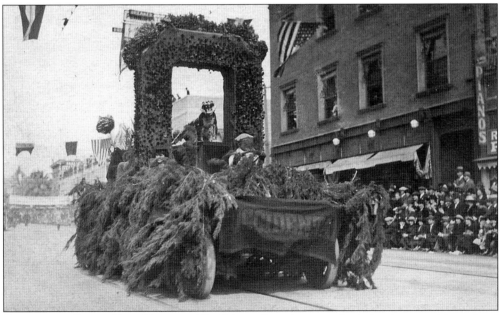

OCCIDENTAL FLOAT, ROSE PARADE. All of the college iconography is in place on this undated float. The tiger-headed mascot rides the rear, and the tiger statue growls surrounded by the big floral "O." The driver perhaps considered himself invisible behind his veil. The parade was less grand in those days, and the strict rules about floral covering were less thoroughly enforced. (Courtesy Stargel Collection.)

REMSEN BIRD BREAKS GROUND FOR HILLSIDE THEATRE, 1924. The Occidental College president seems in a festive mood as he flourishes the "ground-breaking shovel" used since the Highland Park days. Behind him are Harold Wagner (class of 1924, student body president); Thomas G. Burt, dean of the faculty; and two unidentified women. The community was asked to contribute. Many responded, including the Women's Twentieth Century Club, Kiwanis, and the chamber of commerce. (Courtesy College Archives—Occidental College Library.)

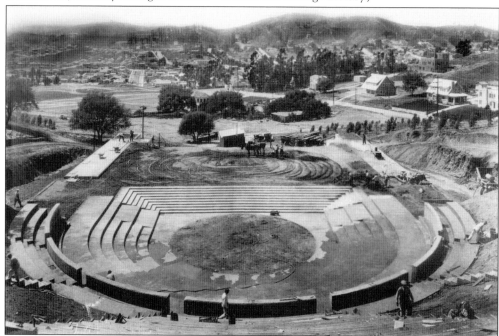

HILLSIDE THEATRE UNDER CONSTRUCTION. Several large houses, often occupied by faculty members, can be seen on the right along Campus Road. The area around and to the rear, which connects to Yosemite Park and Eagle Rock High School, was known then as College Hill. Part of it was donated by Godfrey Edwards. In later years, it has been called Fiji Hill, perhaps reflecting its social use by the Phi Gamma Delta fraternity.

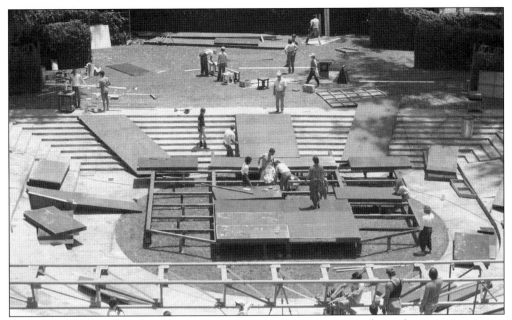

SETUP DAY, SUMMER THEATRE. As the Summer Drama Festival was a traditional repertory company, the setup day was a mandatory workday for the entire company. On the truss in the foreground is Trevor Norton, who grew up with the company, began to be paid at age 11, and worked on the lighting crew for 20 years. When this large lighting rig was first set up, the crew was delayed for days drilling into the massive concrete steps. (Photograph by Josie Dapar.)

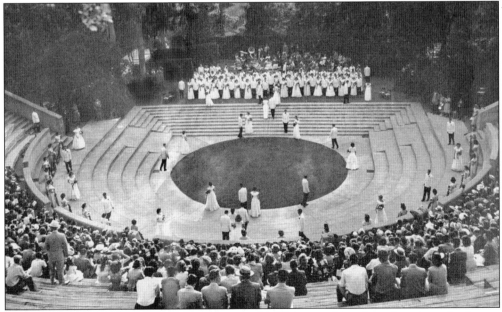

EAGLE ROCK HIGH GRADUATES IN THE BOWL, 1950. This event has taken place since the theater was finished. The graduates are proceeding in order around the aisle and up to the stage to receive their diploma and join their class. The unique tradition of formal wear at graduation was carried on until around 1990, when the then principal decided that it placed too great a financial burden on graduates' families. (*Totem*, 1950.)

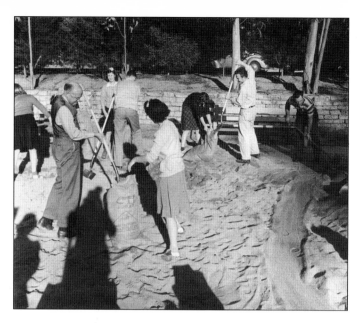

SANDBAGGING, DECEMBER 1941. Dean Robert Glass Cleland and students prepare the college for war. California was never attacked, but the college faced a more subtle danger. Finances became difficult as many students and potential students went off to war. Not only an administrator, Dr. Cleland wrote the second published history of the college and a seminal history of Southern California in the 1870s, *The Cattle on a Thousand Hills.* (Courtesy College Archives—Occidental College Library.)

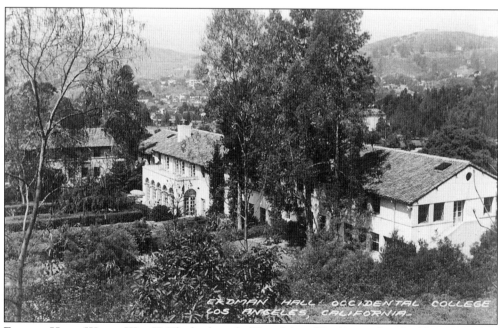

ERDMAN HALL, WORLD WAR II. The back reads, "Dear Mom, Here's one of our buildings. Weather beautiful the last two days—food is wonderful, in all it looks like a good deal. Write soon. Love Bill," signed, "W. R. Hogarty, AS, U.S. NR Navy V-12 Unit." Oxy served as a naval training center as well as maintaining its college programs. Erdman Hall was a women's dormitory, built as part of the campus expansion led by President Bird in the 1920s. (Courtesy Stargel Collection.)

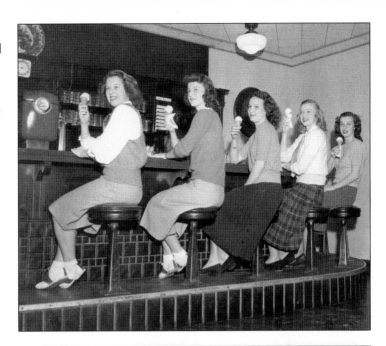

OXY WOMEN IN THE COOLER, 1948. Pictured at the counter from left to right are Joyce Morgan, San Gabriel; Carol Hough, Pasadena; Mary Mundy, Arcadia; Lucille Holmes, Pasadena; and Betty Colwell, San Marino. The Cooler was, and is, a social gathering spot for a snack or drink. This is its first location in the original Student Union. The decor reflects Myron Hunt's design for the college. (Courtesy College Archives—Occidental College Library.)

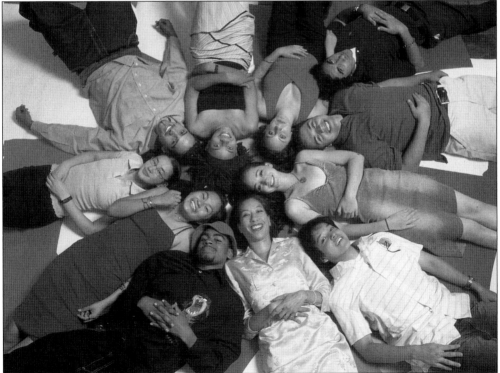

OXY'S MULTICULTURAL INSTITUTE. All of these students attended this program in 2003. They became part of the class of 2007. Shown here with associate professor Elizabeth Chin, bottom center, are (clockwise from the left of Chin) Jonathan Tunstall, Leslie Eskeets, Rosa Yee, Willard Osibin, Kai Small, Paloma Salazar, Bijan Ghaemi, David Luna, Kellyn Adams, and Jonathan Lee. (Courtesy Occidental College Office of Communications.)

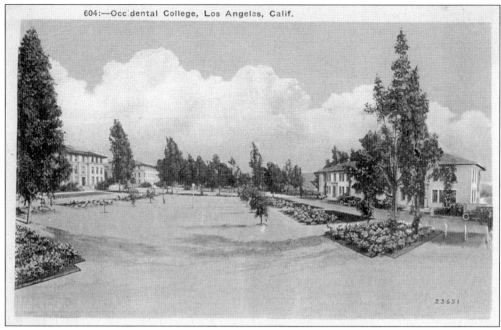

OXY'S MAIN QUAD BEFORE 1924. To the left are Johnson and Fowler Halls; to the right is Swan Hall. The Mary Norton Clapp Library, now at its end, was not yet constructed. Automobiles were allowed on the quad at this time. The beautiful plantings reflect the efforts of architect Myron Hunt to soften this once barren public space. This view was from in front of the old student union. (Published by M. Kashower Company, courtesy Stargel Collection.)

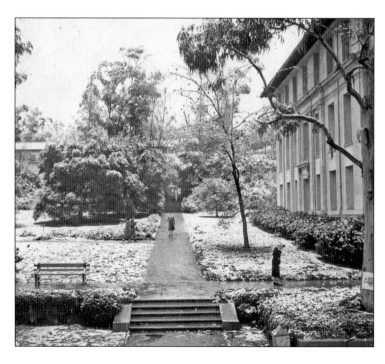

OXY QUIET UNDER SNOW, 1949. Ahead are the dormitories. To the right are the classroom buildings, the library, and Swan Hall, now faculty offices and seminar rooms. Behind the photographer is the Student Union; to the left is the smaller paved quad, often crowded with students sitting on the low wall, lawn, and benches. Everyone passes through this lively space many times a day. (Courtesy College Archives—Occidental College Library.)

DIVING FOR GOLD. Olympian Sammy Lee (class of 1943) won gold medals off the 10-meter board in 1948 and 1952. Also in the 1952 Olympics, Eagle Rocker Bob McMillen brought a silver medal to Oxy in the 1,500-meter run. His coach, Peyton Jordan, led Oxy to 10 conference championships, two top-5 finishes in the NCAA championships, and a NAIA national title in 1956. (Courtesy College Archives—Occidental College Library.)

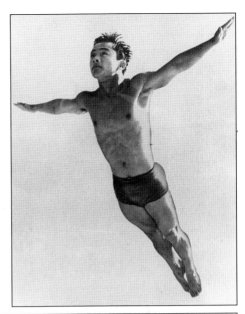

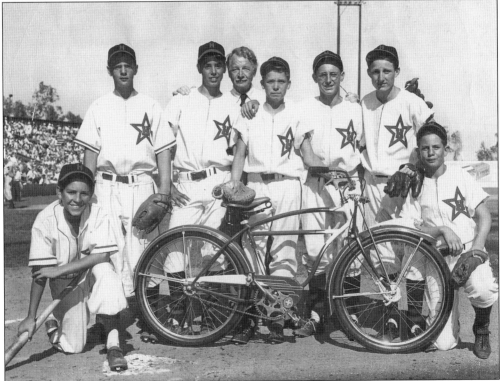

COACH JIM MORA AND FRIENDS. These boys from Eagle Rock put on an infield exhibition at a Hollywood Stars doubleheader. Gary Ferrel, who won, holds the bike. Mora, the tall boy to the left of Ferrel, played football at Oxy with teammate Jack Kemp. After a hitch in the U.S. Marines, he returned to Oxy, was then hired, and after four years became head coach. He then coached in the United States Football League (USFL) and 11 seasons for the New Orleans Saints and 4 more with the Indianapolis Colts in the National Football League (NFL). (Courtesy Mickey Ferrel.)

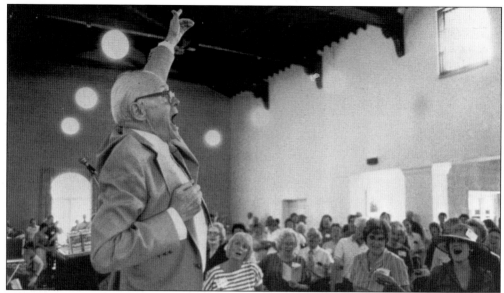

DR. HOWARD SWAN CONDUCTS. Here he has returned to the campus in 1984 to direct his former students in singing the alma mater. This brilliant, inspirational man led the College Glee Clubs from 1934 to 1971. His rather formal manner was belied by the personal interest and memory he had of every student who sang for him. He brought national renown to the college for the quality of its vocal music program. (Courtesy College Archives—Occidental College Library.)

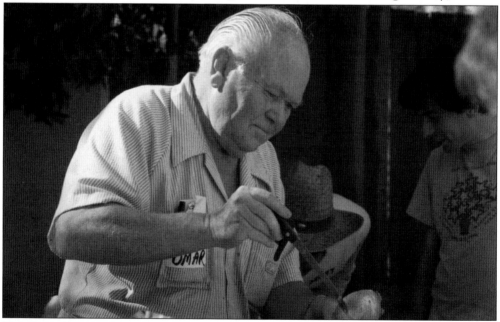

DR. OMAR PAXSON PREPARES A POTATO. After a long-night, marathon setup at the Summer Drama Festival, the company sat down to breakfast. Omar (class of 1948) founded the festival with other alumni and friends in 1960. The shows went on until the end of the 20th century, with Omar in his boiler suit almost always at hand. Says the modest man who has brought more live entertainment to the neighborhood than any other, "Theatre problems are happy problems." (Photograph by Josie Dapar.)

OXY PRESIDENTS GREET JUSTICE WILLIAM O. DOUGLAS. Arthur G. Coons (class of 1920, center), president from 1946 to 1965, and Remsen Bird (right), president from 1921 to 1946, greet the first Remsen Bird Lecturer. An endowment gift was given in 1948 to bring one or more distinguished speakers to the campus every year. Among many others who have spoken are poet Robert Frost and journalist James Reston. (Courtesy College Archives—Occidental College Library.)

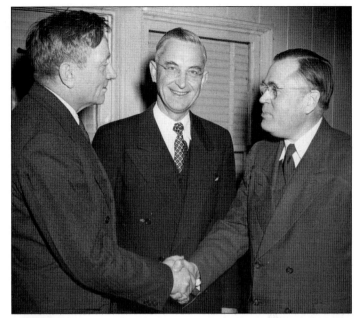

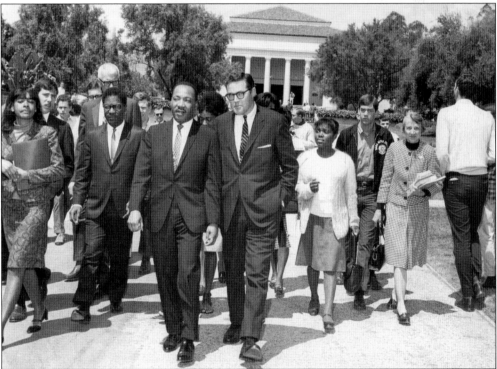

DR. MARTIN LUTHER KING JR. The great civil rights leader walks down the quad with college president Richard Gilman, students, and faculty on April 12, 1967. The civil rights movement and the Vietnam War led to turbulent times on campus. Tensions peaked when students sat in to protest military recruiting; 42 were expelled. Some returned; some never did. One, Rex Wyler, a founder of Greenpeace, was honored recently by the college Center for Urban and Environmental Policy. (Photograph by Joe Friezer.)

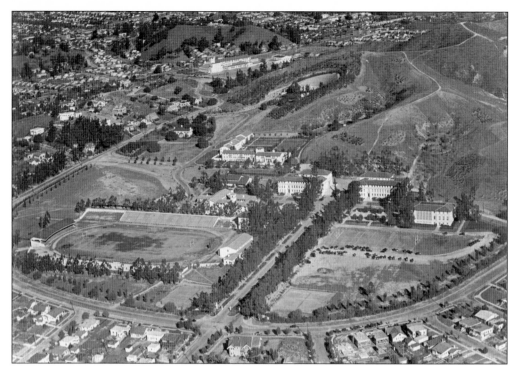

AERIAL VIEWS, 1928 AND 1961. The earlier view above shows Oxy completed to Myron Hunt's original plan. Alumni Avenue stretches onto the campus, where it is crossed by the Main Quad, focus of the academic buildings. The early dormitories extend up the hill to the left. The president's house is isolated up to the left near Campus Road. Eagle Rock High is in the center distance. Below, the campus has expanded to the right with modernist buildings at the end of the quad and new dormitories up the hills. Colorado Boulevard is at the top, slightly converging with Yosemite Drive. Eagle Rock Boulevard is hidden on the left. The college would continue to grow up into the hills and to the left. (Courtesy College Archives—Occidental College Library.)

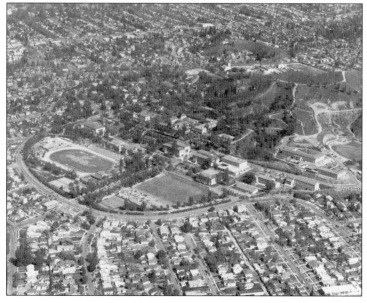

Six

THE VALLEY OF THE ROCK

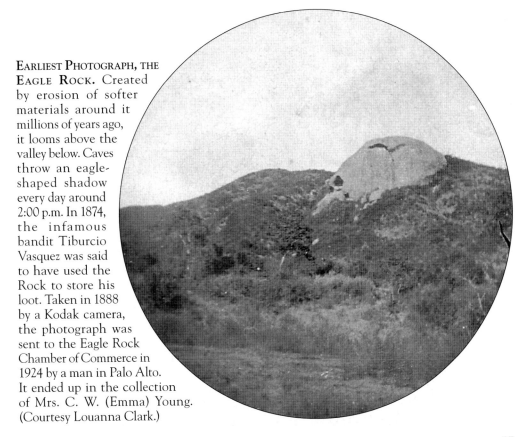

EARLIEST PHOTOGRAPH, THE EAGLE ROCK. Created by erosion of softer materials around it millions of years ago, it looms above the valley below. Caves throw an eagle-shaped shadow every day around 2:00 p.m. In 1874, the infamous bandit Tiburcio Vasquez was said to have used the Rock to store his loot. Taken in 1888 by a Kodak camera, the photograph was sent to the Eagle Rock Chamber of Commerce in 1924 by a man in Palo Alto. It ended up in the collection of Mrs. C. W. (Emma) Young. (Courtesy Louanna Clark.)

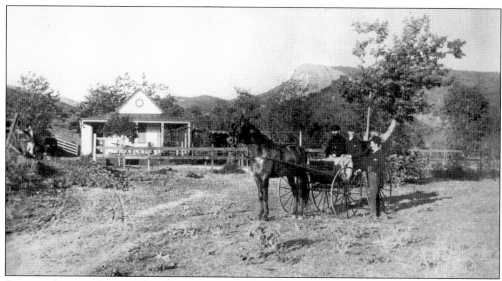

STEWART RANCH. It is said that this property may have been occupied by a man named Dominguez during the rancho days; if so, it would descend from the oldest residence in Eagle Rock. The ranch was located just north of La Loma Road, on what is now the power line easement. The cover of this book shows a broader view of this area.

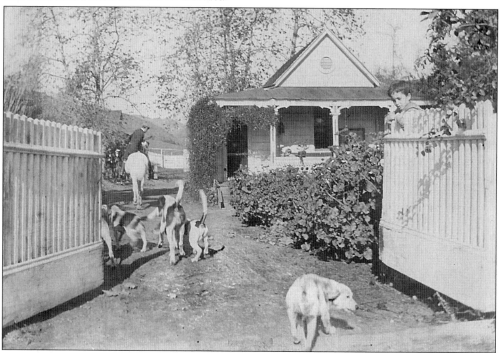

RENTED BY LETCHWORTHS. The old house is considerably more domesticated here in 1906. A member of the Valley Hunt Club, originators of the Tournament of Roses Parade, Pierre E. Letchworth rides out with his foxhounds on Monte. The Richardsons had purchased the house, enlarging their property to the west. In the summer of 1906, they gave the house to their daughter Elizabeth and her new husband, Fred Hannaford. Both properties were soon sold to the Huntington Land Company. (Courtesy Pierre Letchworth.)

LOOKING OVER OAK GROVE DRIVE TO THE ROCK. The geography of the valley can be seen clearly. The stream flows from between the rock and the hills to the right under the bridge, creating the wet woodlands at the right edge of the photograph. There it joins the drainage of the La Loma Road canyon and sweeps left back into the picture, proceeding left down the Yosemite Valley. The bridge, built by Harry Warrington and in front of the Rock, allowed easy passage on high ground to the Arroyo Seco Bridge beyond. The house in the lower center of the picture then ended Yosemite Drive. Oak Grove Drive connected to Figueroa Street in the upper foreground.

"W" LINE TRACKS. The line was built in 1910 and extended in 1913 to supply the construction of the Pacific Power and Light power station, in the valley between the Rock and the hills to the left. The line came from downtown Los Angeles via Pasadena Avenue and Figueroa Street, seen before its realignment on the left. It ran to the company-owned park, on Sundays only, until 1937. Figueroa Street and Buena Vista Terrace was the terminus on weekdays until the line was converted to buses in 1948. (Courtesy Danny Howard.)

EAGLE ROCK PASTORAL SCENE. Sheep graze along the side of a hill on the south side of what is now Figueroa Street. The photograph is deceptive. The Pacific Power and Light power station can be seen in the distance, the billboarded road to Pasadena is through, and a large cross stands on top of the rock. It must be after 1917 as urbanization is well along. (Photograph by Charles H. Beam, courtesy Security Pacific Collection, Los Angeles Public Library.)

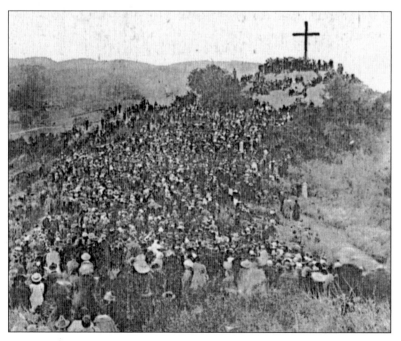

EASTER SUNRISE, 1918. The crowd hikes up the back side of the Rock. The first such service in Southern California and the second in the United States was held at the Rock in 1917. Services were discontinued here in the late 1920s when a deed restriction against religious services on the property was discovered. (*Eagle Rock Sentinel.*)

ANNETA LORENZ GATHERS FLOWERS. The hills near the Rock were covered in spring wildflowers. This high meadow is now probably the site of the Eagle Rock Reservoir. (Courtesy Elmer Lorenz.)

Eagle Rock Park,
Los Angeles, California.

PARK BELOW THE EAGLE ROCK. Visible to the left center is the bridge that led from Eagle Rock to Pasadena. This was the easiest crossing of the highly variable stream seen in the foreground. The stream still flows in the open through the Metropolitan Water District land, under the dump road, and behind the commercial buildings on the east side of Figueroa Street just below the 134 Freeway exit bridge.

SUBSTATION EXPLOSION, 1923. Henry Huntington's Pacific Power and Light Company constructed this building and its switchyard in 1913 as the southern terminus of the Big Creek project, the largest privately owned hydroelectric project west of the Mississippi. Power from the dam 100 miles north would supply his trolley lines. A lightning arrestor failed after Edison upgraded the voltage of the transmission lines. The station was rapidly restored and still delivers power to the area today. (Courtesy Huntington Library, Southern California Edison Collection.)

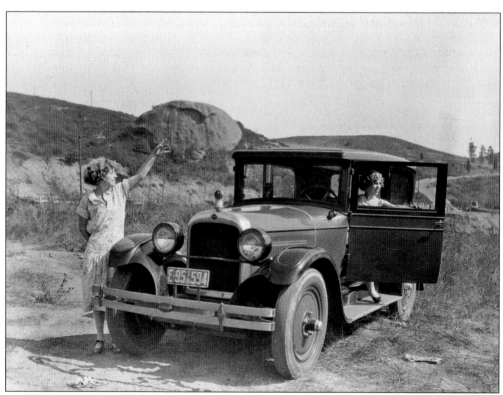

SIGHTING THE ROCK. On the route to Pasadena, these women stop to enjoy the view. Colorado Boulevard winds behind them, past the intersection with Annandale Boulevard (now Figueroa Street)—seen at the edge of the door—across the bridge and up the hill heading for the Annandale Country Club, Sternberger's Restaurant, and the Colorado Street Bridge. (Courtesy University of Southern California Library, California Historical Society Collection.)

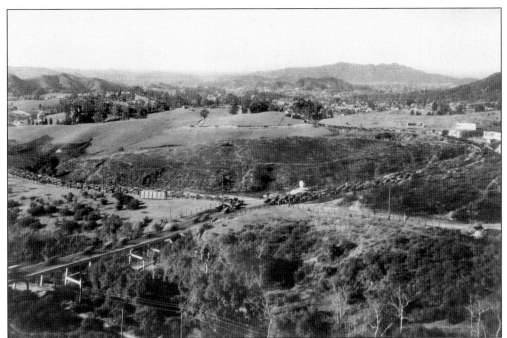

HEAVY TRAFFIC. This image was probably shot from the top of the Rock on January 1, with people going to the Rose Parade or Rose Bowl. Colorado Boulevard then followed the route of today's Eagle Vista Drive. The Eagle Rock Recreation Center now occupies the knoll in the center. The bridge across the stream is located about where the 134 Freeway bridge is now.

LA PALOMA, 1932. As its contribution to the Olympic festivities, a committee of notables from Eagle Rock and Occidental College asked Dr. Ben F. Sherman to write and direct an outdoor play. Originally intended for the Occidental Bowl, four performances were produced in the natural amphitheater at the foot of the Rock. Presenting the "American conquest of Southern California," it was "a story of romantic charm and historic lore" with a cast of over 200, according to a *La Paloma* advertising flyer. (*Eagle Rock Sentinel.*)

FLOODING, YOSEMITE DRIVE. Heavy rains drenched the region, and the forces that had revealed the Rock roared to life on the night of January 31, 1934. The stream normally ran quietly past Rockdale School, along Yosemite Drive, down Eagle Rock Boulevard, and into the swampy area near York and Eagle Rock Boulevards. The scale of the damage showed the need for planned drainage.

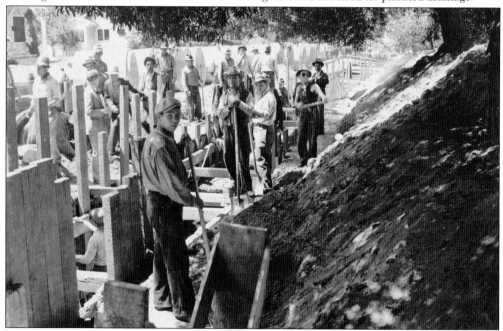

STORM DRAINS, 1938. On Avoca Street near Yosemite Drive, WPA workers rest from their labors. The large concrete pipes were buried in a trench apparently dug entirely by hand. This was probably the first underground drain for Eagle Rock's surface waters. Work would continue into the 1960s. None of the streams and springs in the Eagle Rock and York Valleys are visible today. (Courtesy University of Southern California Library, California Historical Society Collection.)

PIPELINE DOWN THE CANYON. From 1936 to 1938, the Colorado River came to the canyon behind the Rock. The Metropolitan Water District Aqueduct came through Pasadena underground, surfacing in a valving station at the edge of the canyon, where it split into two branches. One runs via Scholl Canyon and terminates in Santa Monica. This 55-inch conduit heads down the canyon, under the old trolley right-of-way, and along Figueroa Street and terminates in Palos Verdes. These lines deliver a majority of the region's water today. (Courtesy Metropolitan Water District.)

EAGLE ROCK RESERVOIR. The facility was dedicated on August 18, 1953. Built to allow the City of Los Angeles to use its allocation from the Colorado River Aqueduct, it feeds a pipeline that runs under Colorado Boulevard to the Silverlake Reservoir. Construction erased the canyon and high meadow area at the end of Eagle Vista Drive, probably the one shown on page 91. The reservoir is dry today. Regulations forbid the surface storage of drinking water.

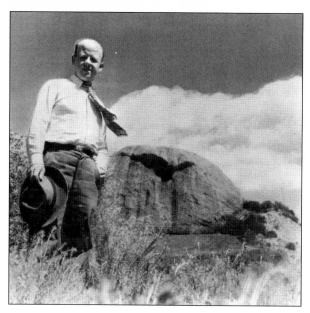

FRANCIS R. LINE. "Someday we want the Rock and its surroundings to be one of the beauty spots of the country . . . plans must await the return of peace," Line said. He built a path up the back and for a time opened it to sightseers. Line, a nationally known lecturer and documentary filmmaker, purchased the Rock and 13 acres around it in 1944 from Alonzo C. Mather. Mather bought the land from the Campbell-Johnston's San Raphael Land Company in 1925 and planned to build a resort hotel. (Courtesy Herald-Examiner Collection, Los Angeles Public Library.)

EAGLE ROCK RECREATION CENTER CLUBHOUSE RENDERING, 1953. The dream of a park near the rock was fulfilled in 1954 when this clubhouse on a large site across Figueroa Street from the earlier "park" opened. Richard Neutra's post-and-beam building featured a stage that opened to the large gym, an outdoor amphitheater, and a smaller meeting room. The counterweighted walls of the gym could be raised for ventilation. The building was in many ways the culmination of the architect's classic approach to modern building. Garrett Ekbo designed the grounds, which were completed in 1959. (Rendering by R. C. Quale.)

PROTESTING THE DUMP, 1959. Edwin Adams, at the microphone, presents a resolution to Councilman John C. Holland (left). The ending of incineration for trash disposal forced a search for alternate methods. The county proposed Scholl Canyon in Glendale as a site for a regional landfill. The residents of Glendale's Glenoaks Canyon refused to allow truck access. After strenuous protest, Eagle Rock got the access, and the canyon stream, the focus of dreams of a park, was buried under 20 feet of fill. (Photograph by Joe Friezer.)

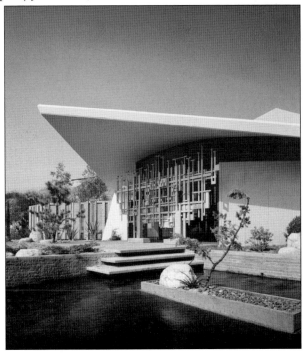

JAMES REAL STUDIO, 1959. When he bought the Rock and 2.5 acres of industrial-zoned land from Line in 1957, Real envisioned the construction of a laboratory for technological innovation. He built his studio first. Arthur Lavagnino designed the building, with sculptural elements by local artist Jan De Swart. The Pacific Bridge Company fabricated the innovative concrete roof design. Later Real built two modernist apartment buildings. (Photograph by Julius Shulman, courtesy J. Paul Getty Trust, Julius Shulman Photography Archive.)

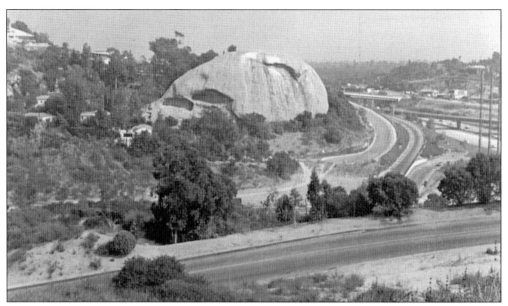

THE ROCK SURROUNDED. Francis Line offered the Rock to the city in 1957 for $28,000. This paint vandalism led the Community Improvement Committee of the Women's Club to ask again that the city purchase it. The city declared the Rock a Historic Cultural Monument in 1962. After James Real's death in 1982, his land was sold to a developer who proposed building 20 condominiums. Picketing by The Eagle Rock Association and fund-raising by a coalition of community groups, culminating in a pancake breakfast, raised thousands. The support of Mayor Tom Bradley and Councilman Richard Alatorre finally led the purchase of the Rock for $699,000 in 1995.

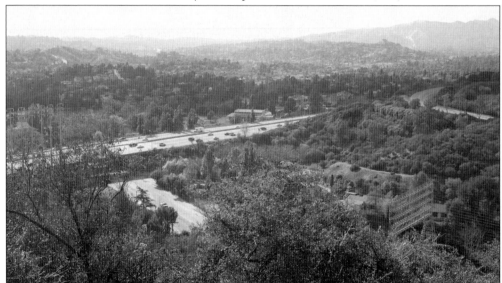

VIEW FROM THE TRAIL. John Stillion and the Collaborative Eagle Rock Beautiful heard that a 4-acre property to the northwest of the Rock was available. They began the purchase of the land with the funds raised in the 1980s to "Save the Rock." The land was groomed, and community members, working with master trail builder Peter Schaller, constructed a trail to the top. This photograph looking over the valley, 134 Freeway, and the community to the city beyond was taken in 2008. (Photograph by Harry Chamberlain.)

Seven

From Main Street to Metropolis

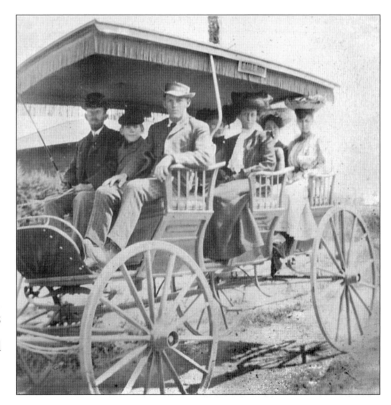

EAGLE ROCK'S FIRST
BUS. The route ran
from Townsend
Avenue and Eagle
Rock Road (Colorado
Boulevard) over the
hill into the valley
of the Rock, over
the stream, and up
the hill to Avenue
60 in Garvanza in
the early 1900s.
Pictured from left to
right are (front seat)
driver Otto Owen
and Bob and Bill
Broxhelme; (middle
seat) unidentified and
Mrs. R. U. Frackelton;
(back seat) Emilie
Broxhelme and Mabel
Myers. (Courtesy
Elena Frackelton
Murdock family.)

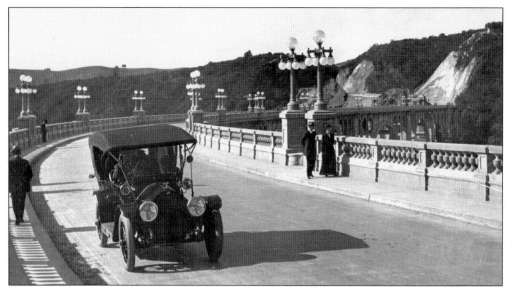

COLORADO STREET BRIDGE. Opening in 1913, across the Arroyo Seco, the Colorado Street Bridge reduced travel time to Pasadena from a full day to minutes. The rerouted and renamed Figueroa Street and Colorado Boulevard became major highways. The intersection of Colorado and Eagle Rock Boulevards became the center of commerce in Eagle Rock. The dual nature of the boulevards as main street and highway was born. This has been a source of prosperity and conflict until the present day.

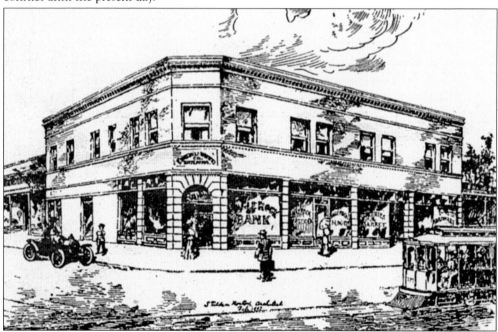

FIRST COMMERCIAL BUILDING. This rendering by architect S. Tiden Norton embodies the hopes of Edwards and Winters, its developers. It was to house the Eagle Rock Bank, Water Company, and Land Company among others. Long known as the Murfield Block and now housing Tritch Hardware, the building was constructed in 1907 at the end of the new trolley line at Townsend Avenue and Eagle Rock Road. (Courtesy Elena Frackelton Murdock family.)

A Realistic View. Isolated at the end of a widened but still dirt street, the trolley line ends at Townsend Avenue and Eagle Rock Road (Colorado Boulevard) soon after the line opened in 1906. Townsend Avenue was named for a family that lived north of this intersection. Behind the photographer, Eagle Rock Road to Garvanza and Pasadena was small and unimproved. (Courtesy Elena Frackelton Murdock family.)

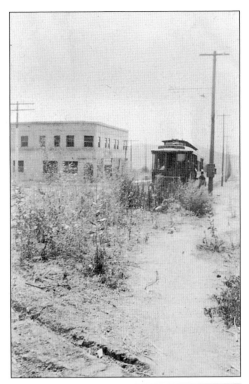

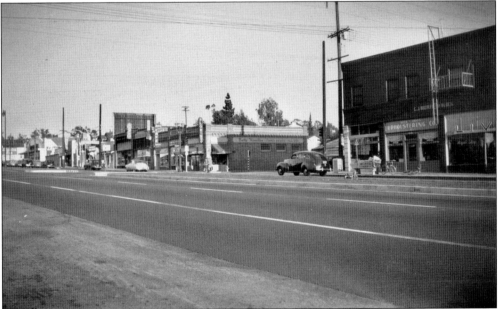

Colorado and Townsend, 1949. A year after the trolley tracks were removed, at the far left stands the Shopping Bag Market (Trader Joe's). The line of small stores to the right of the market dated from very early in the city's history. Most notable was the beautiful tapestry brick building on the corner, which housed Eagle Rock's original city jail. The corner was demolished for a mini-mall in 1986, precipitating the formation of The Eagle Rock Association. The C. J. Murfield Building is at the right. (Photograph by Alan Weeks.)

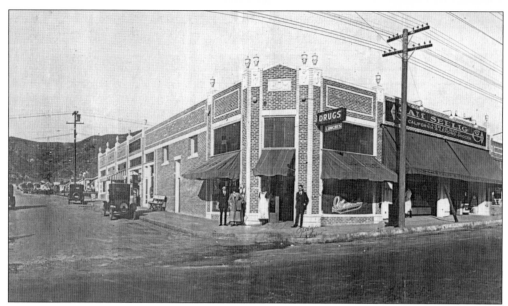

NORTHEAST CORNER, TOWNSEND AND COLORADO, 1924. The building houses Stine's Drug Store and Sam Sellig's Market. Stripped of its finials, its decorative brick was covered with stucco in the art deco style sometime in the 1930s. Many remember it as the Economart. Part of Eagle Rock's first commercial district, it serves as a retail block again after an interval as an auto repair center.

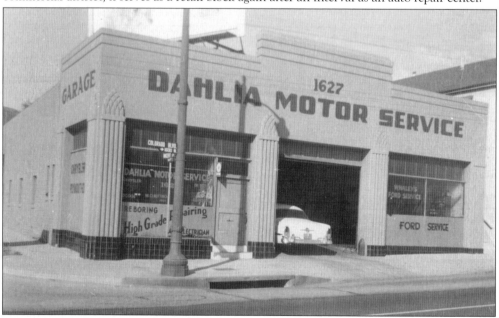

DAHLIA MOTORS BUILDING. Dahlia Motors Building was constructed by Nancy Poole in 1931 for Wayne Nutting. Here Whaley's Ford Service takes equal billing. Nutting owned and drove a Stanley Steamer, giving rides to local children on his weekend jaunts. He and his wife were killed and several others were badly injured in an accident involving a propane retrofit on the car. The last garage owner was La Dell Stapp. When he retired, he sold the building to the present owners, who refurbished it, had it declared a Historic Cultural Monument, and opened Fatty's, a Place to Eat.

Joe "Kookie" Kopietz at his Station. The gas station building is gone. Kopietz lived behind the station in a small house, which remains. Many independent stations existed to service local cars and the traffic on Colorado Boulevard and Figueroa Street. Both streets were at one time part of Route 66.

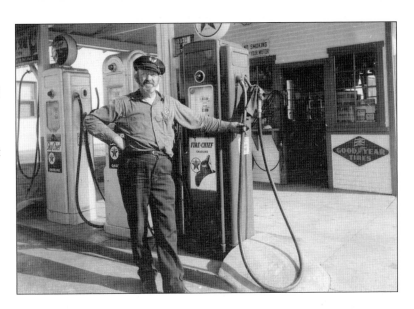

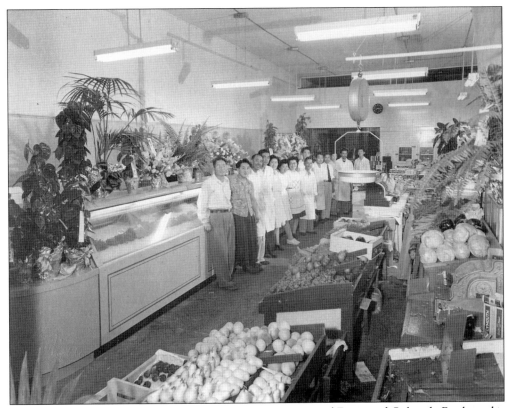

Ito Brothers Produce Market. The interior at Mount Royal Drive and Colorado Boulevard is shown here. This Japanese American family was prominent in the produce and grocery business on the boulevard. Like most others, they lost their homes and businesses when they were relocated in 1941. This family was sent to Manzanar. Though many family members returned to the area, they never regained their stores. (Courtesy Kiyuko Luster.)

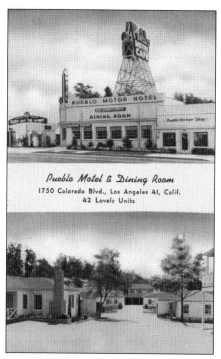

Pueblo Motel. Catering to the increasing highway traffic on Colorado Boulevard in the 1930s and 1940s, its Streamline Moderne facade and giant sign advertises it as a roadside attraction. The cabins appear to be of earlier origin. The motel still stands, having served as a halfway house in recent years. A new use for the property is being sought.

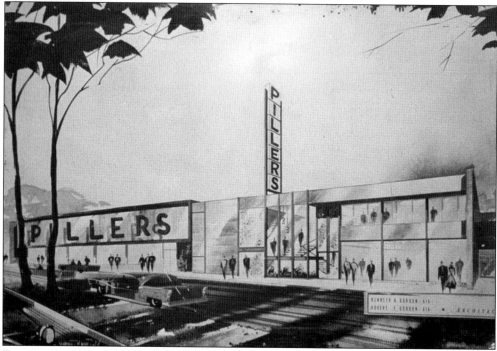

Rendering of Piller's Store. Clearly the intent was to appeal to customers in cars. An adaptation of an earlier Safeway market and its parking lot, the new building, by architects Kenneth and Robert Gordon, featured prominent signage and free parking. This family-owned business offered closeouts and discounted shoes and clothing gathered from throughout the city. The Renaissance Academy, a charter school, now occupies the building. (Rendering by Roscoe W. Martin.)

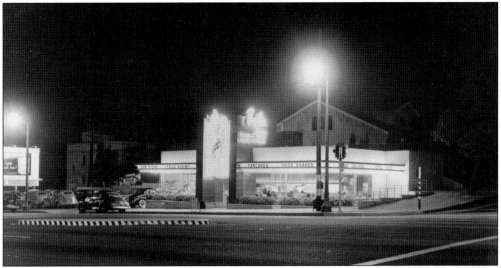

Bob's Restaurant, 1950. The popular hangout for the community, particularly the baby boom generation, was a branch of the business created in Glendale by Bob Wian. The postwar modern structure had an adjoining parking lot and facade designed around a large sign and "Big Boy" icon. These features, oriented toward the street, show the expectation that customers would be attracted by highway visible signage and would arrive by car.

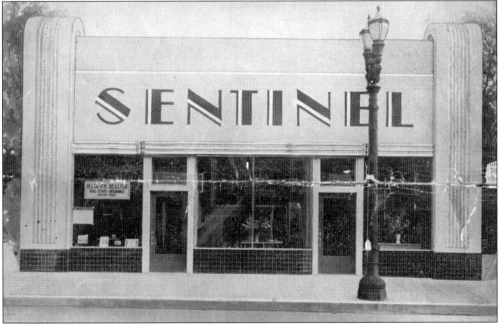

Eagle Rock Sentinel Building. Eagle Rock's main newspaper was published from 1910 to 1997. Built as the headquarters for this flourishing business in 1937 by Harry Lawson, this art deco building also housed an associated job printing business and, for a little extra income, H. I. Du Vol's real estate office. This signature building still stands and was recently refurbished. The Carrara glass sign has been covered to allow advertising of contemporary businesses. Oran W. Asa acquired the paper in 1957. He consolidated it into Northeast Newspapers, headquartered in Highland Park.

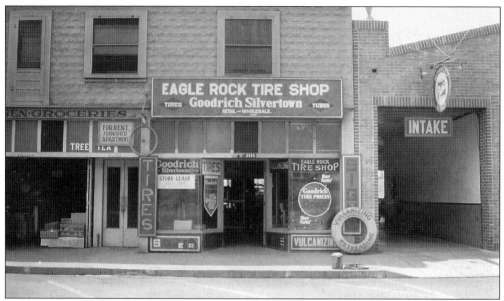

EAGLE ROCK TIRE SHOP, 1923. Bill White, a friend who was leaving town as a result of a marital dispute, gave George Juett a bicycle repair shop and tire store as a means of financing his education. Juett became a successful business investor and later a professor at Pasadena City College. The business began here and later relocated across Colorado Boulevard as Juett-Clements-Lenney. (Courtesy Esther Juett.)

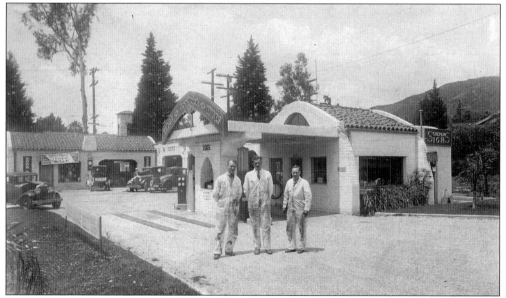

JUETT-CLEMENTS-LENNEY. Dick Clements stands between two unidentified mechanics in this early photograph of the largest auto service business in Eagle Rock. Juett purchased the property and moved the business. They soon felt the need of a mechanic and brought in Fred Lenney, who worked at the Ford dealership down the street, as a partner. Lenny brought with him a large customer base, which necessitated the building of a garage facility that extended the business to Sherin Avenue. Jim's Burgers, now Oinkster, was built here. (Courtesy Peggy Lenney and the Clements family.)

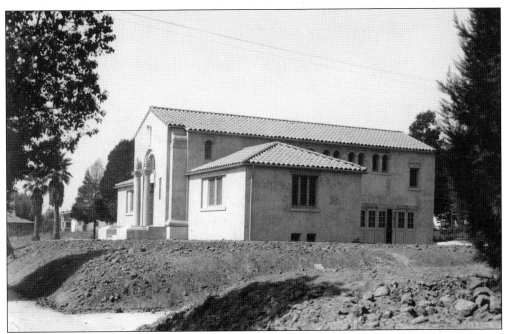

EAGLE ROCK CITY HALL, 1922. This was designed by architect William Lee Woollett to house the city services of Eagle Rock City. Annexation to Los Angeles won by 15 votes out of 600 a year later. It was refurbished and rededicated in 1971 at the urging of the historical society and Councilman Arthur K. Snyder. It became the councilman's office, the historical society's museum, and a public meeting hall. Earthquake strengthening necessitated another closure; afterward the building was taken over entirely for city offices. (Courtesy Security Pacific Collection, Los Angeles Public Library.)

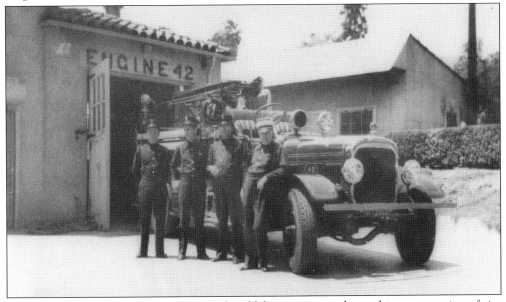

MEN OF ENGINE COMPANY 42 IN 1949. The old fire station was located in an extension of city hall, where they are standing with their truck. This obsolete addition was removed and the present modern brick-faced building was constructed in 1959.

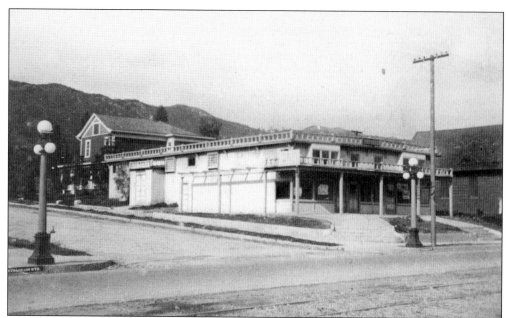

SYMPHONY HALL. The building at Colorado Boulevard and Caspar Avenue was a center of Eagle Rock life. It housed Swan's Dry Goods, an early location of the post office; upstairs was a community meeting hall. This later photograph, perhaps when the building was for sale, shows part of the remodeled Methodist church to the right. Behind it is the funeral home that was later purchased and used by the Methodists as a parsonage and Sunday school.

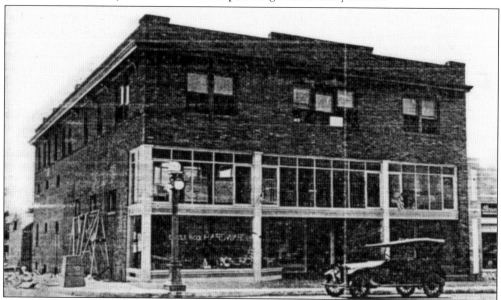

RITCHEY'S EAGLE ROCK HARDWARE. Built to replace the one-story Ritchie and Grotthouse Block, this three-story structure was the largest on the boulevard for many years. The tall glazed-wooden storefront showed the merchandise to full advantage to passing shoppers. The interior featured a two-story atrium with a second-floor gallery all around. The building, which then housed Colorado Furniture and the YMCA upstairs, was almost destroyed by fire in 1944. It was restored as a two-story building, which exists, much modified, today.

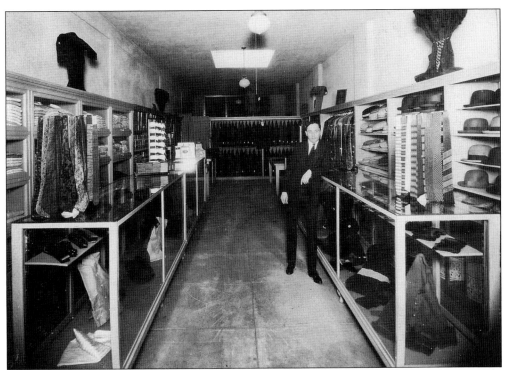

ARTHUR ROBERTS IN HIS STORE. Art Roberts had invested $400 in inventory and $40 in rent to open in 1921. When Roberts had a heart attack, nephew Bernard Krom came to help Roberts's widow, Edna. A dynamic salesman and entrepreneur, over the decades Bernie expanded the Roberts shop into two, then three, and then four storefronts. The group was completely remodeled in 1960. It is now a real estate office. (Courtesy Bernard Krom.)

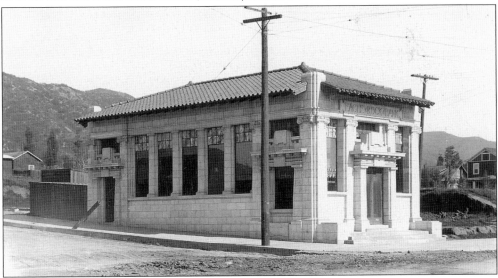

EAGLE ROCK BANK. Its move from Townsend Avenue signaled the shift of the center of business to Eagle Rock and Colorado Boulevards around 1911. The earlier perception that business would be best at the end of the trolley line was superseded by the greater centrality of this intersection, its major road junction, and trolley lines to both Los Angeles and Glendale.

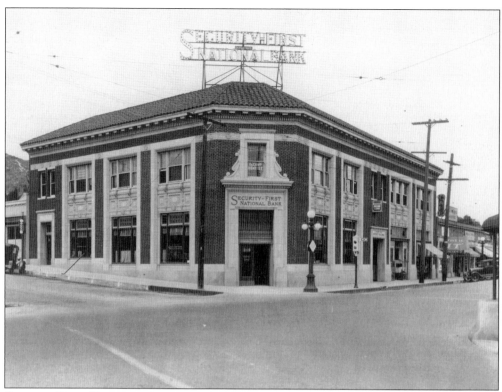

SECURITY BANK BUILDING. Constructed in the 1920s, it succeeded the Eagle Rock Bank. This beautiful building anchored the northeast corner of Eagle Rock and Colorado Boulevards. Its demolition in 1970 sacrificed quality architecture to build the lower-profile bank building, with side access to parking, which stands today. It is now a Blockbuster Video.

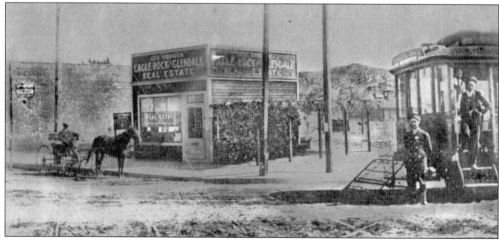

SOUTHWEST CORNER, EAGLE ROCK AND COLORADO BOULEVARDS, 1909. George Diddock's real estate office is on the corner; he and James Ferdon constructed the earliest buildings on this block. Both streets are unpaved. The side of Ferdon's College Inn building is visible on the left. In the center right, the newly built Eagle Rock School is visible in the distance. On the right is the Los Angeles Railways trolley from downtown, heading for the end of the line at Townsend Avenue. (*Los Angeles Herald Sunday Magazine.*)

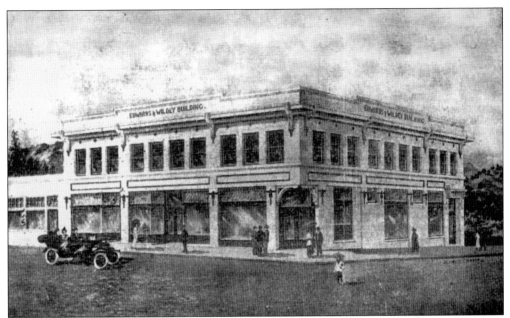

EDWARDS AND WILDEY BUILDING. This 1915 architect's rendering shows the new glazed-brick building, the anchor for the business district from 1916 until today. It was built across Eagle Rock Boulevard from their earlier raffish real estate office. The building housed a drugstore on the corner until the 1990s; the soda fountain here was a hangout for young people between the wars. The building appears much like this today except for changes to the store facades on the left end in the 1950s.

WARTIME FLAG CEREMONY, DECEMBER 15, 1917. Men and women from Eagle Rock have fought and died in all of America's wars from then until now. The young men stand with the flag across Colorado Boulevard from the new Edwards and Wildey Building. The College Inn building is to its left, and the Ritchey and Grotthouse Hardware store is on the corner at Caspar Avenue.

EAGLE ROCK AND COLORADO FROM THE NORTH, 1927. The "Merry Go Round" trolley waiting area remained until it became too much of an encumbrance to the increasing automobile traffic. The cars and gasoline station show growth in such traffic even then. Colorado Boulevard and Eagle Rock Boulevard south of the intersection were now paved. The north (residential) part of Eagle Rock Boulevard remains dirt. The first office of the *Eagle Rock Sentinel* is on the left behind the new Security Bank building. (Courtesy Security Pacific Collection, Los Angeles Public Library.)

NEW END OF THE LINE, 1948. The tracks to Townsend had been removed. On the corner is the art deco–style second Bank of America building. Constructed in 1937, it anchored this important corner until the bank moved across Colorado Boulevard to the remodeled Model Market building where it remains. Davis Pharmacy briefly occupied the corner. A gas station replaced it, anticipating the increased traffic generated by the new freeway. (Photograph by Alan Weeks.)

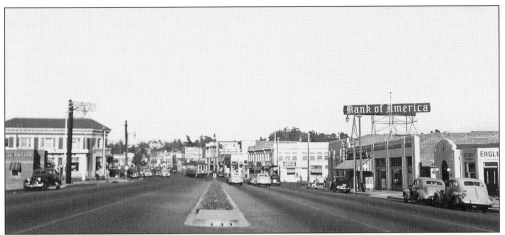

THE INTERSECTION, 1949. The war was over and business was good. The Security Bank building stands at the left, the Citizens Chevrolet sign dominates the distance, and the Ritchey Hardware building (then a furniture store) is still at the corner of Colorado Boulevard and Caspar Avenue. The Edwards and Wildey Building is without the billboard that it holds today. The Bank of America is on the corner with the Shopping Bag Market adjacent. Phinney's real estate office is on the right. (Photograph by William T. Phinney.)

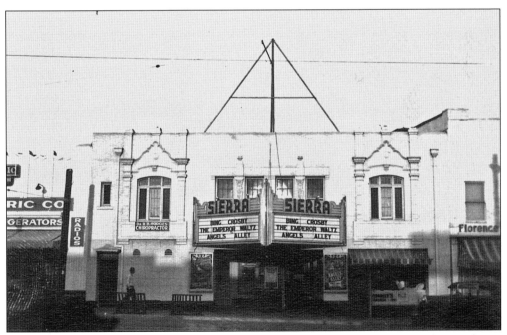

SIERRA THEATRE. The theater had several names. It was originally the Eagle Rock Theater, shown obliquely on page 114. By 1948, business had slipped, the vertical sign was removed, and it was known to its young patrons as "the dirty dime." The building was torn down around 1960 and replaced by two conventional storefronts. Part of the old Mason's Hall can be seen on the right.

OLD MASON'S HALL. James Ferdon built this for the Masons in 1913. This picture must have been taken soon after that, as the building is very isolated here on Eagle Rock Boulevard. The building still exists with the cornice decoration removed and windows replaced. The Masons moved into a larger hall on Caspar Avenue. They were later consolidated with the South Pasadena Lodge. Note the trolley wires and unpaved street.

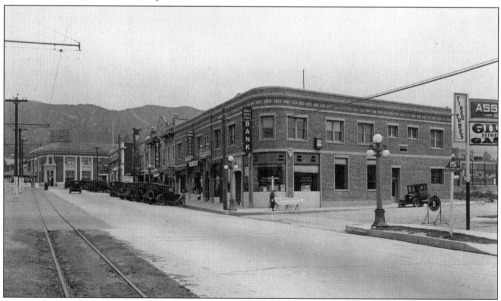

LOOKING NORTH ON EAGLE ROCK, C. 1927. James Ferdon's Bank of Italy Building is in the foreground. It features some fine detailing. Ferdon's family ended up living in the upstairs apartments in the 1930s, until Mrs. Alpha Ferdon was able to trade the building for a house in Pasadena. After the bank moved, the *Eagle Rock Advertiser* was published here. The paper closed in 1949, but publisher Paul Bailey and his Wasternlore Press occupied the corner for many years after. The vertical sign of the Eagle Rock Theatre, topped by an eagle, is left of center.

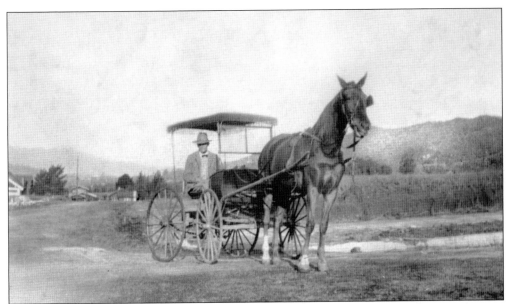

JOHN H. DRENGBERG. Eagle Rock's first postman, Drengberg retired after 14 years on his route. He watered his horse at the trough in front of the drugstore in the Edwards and Wildey Building. The rural route replaced the earlier customer pickup at Swan's Dry goods in Symphony Hall. This photograph's location, which shows a very rural landscape, is unknown.

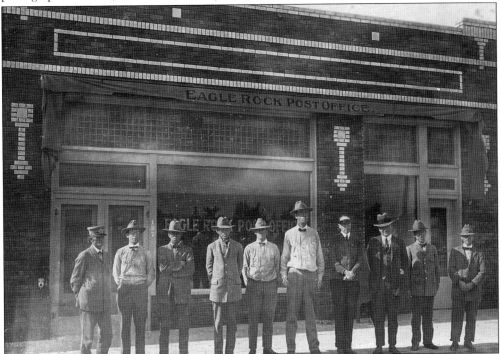

EAGLE ROCK POST OFFICE, 1922. This was probably the first building constructed for that purpose. Rural route driver John H. Drengberg is seen on the left. Marvin Hensel is second from the left. The building is now an auto repair shop. It stands, well preserved, on Eagle Rock Boulevard. (Courtesy Mrs. Marvin Hensel.)

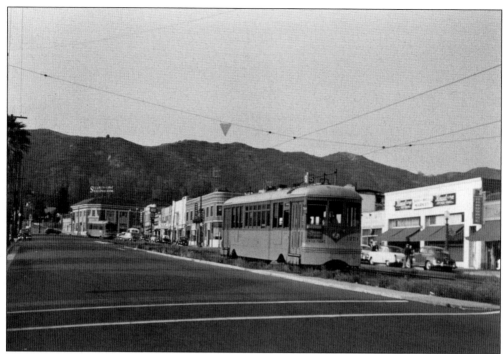

TROLLEY AT CHICKASAW AVENUE, 1948. The Serve-Well Market is in the right foreground. Run by the Wong family, the market was the last family-owned, open-front market on the boulevards. It lasted in this location until the late 1950s and then moved to Broadway where a Chevron station is today. The family purchased a home on Saginaw Avenue near Rockdale School in the early 1920s. (Photograph by Alan Weeks.)

SCHOLFIELD AND SHEPARD AT EAGLE ROCK BOULEVARD AND CASPAR AVENUE, 1947. Juanita A. Bell owned the business, purchasing it from a Mrs. Scholfield. Bell was one of several Eagle Rock women prominent early in the real estate business. This form of office, a small building (often a converted residence) with lots of advertising space, was fast disappearing as the land it sat on became more valuable. (Courtesy Warren family.)

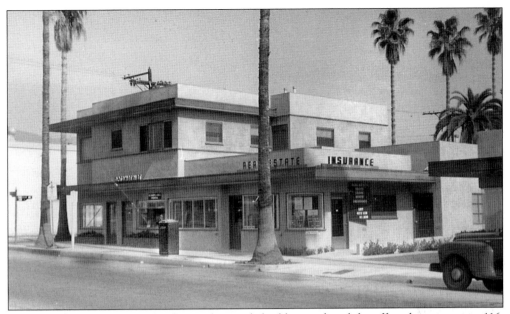

POSTWAR MIXED USE. In 1956, this modern-style building replaced the office shown on page 116. This continued the tradition of mixed-use retail development seen in many earlier buildings. Balconies were included with the apartments to allow residents a bit of outdoor space. The building partially shown at right was constructed in 1954 in similar style. Bell and her daughter and son-in-law, Bettie Lou and Robert H. Warren (the author's parents), built it to house their growing businesses as well as provide income. (Courtesy Warren family.)

EAGLE ROCK LUMBER COMPANY, 1920. The street to the right is Eagle Rock Boulevard with Fair Park Avenue in the center. Emil Swanson bought the business in 1917. The yard across the street is another lumber business, which Swanson purchased and merged. Moved across Fair Park Avenue for the construction of the Eagle Rock Shopping Center in 1964, it remains the oldest operating business in Eagle Rock. (Courtesy Kevin Strouch and North Swanson.)

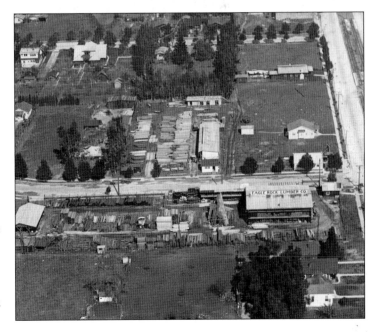

NEW LUMBER OFFICE. Emil Swanson built this log cabin–style building in 1924. He sold these bark-on boards as a sideline. His home was also in this rustic manner. Swanson was an avid outdoorsman; this may have contributed to his enthusiasm for this style. An early and longtime member of the chamber of commerce and a founding member of the Eagle Rock Kiwanis Club, he was president of both of these organizations several times. (Courtesy Kevin Strouch and North Swanson.)

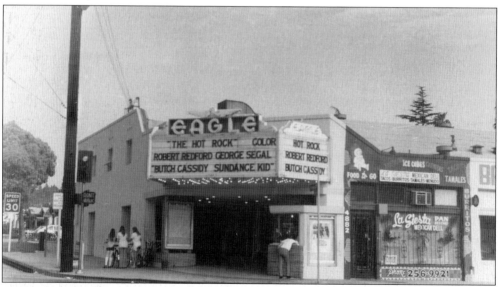

EAGLE THEATER. Designed in a Mediterranean style by architect Kenneth A. Gordon, with an interior painted as a patio garden, the Eagle opened as the Yosemite Theater in 1929 with two days of vaudeville, headlined by local Scottish singer George Vallance. It was equipped for sound in 1930. In 1940, the name was changed to the Eagle Theater. In the 1970s, it was purchased and restyled by the Pussycat Theater chain, but public outcry prevented them from booking it. They rented to independent operators who operated it until 2001. It is now a church. (Courtesy Security Pacific Collection, Los Angeles Public Library.)

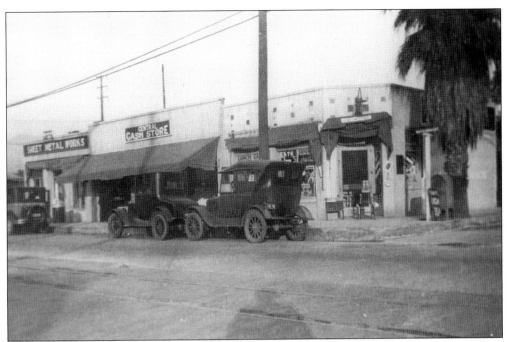

ADDISON WAY AND EAGLE ROCK BOULEVARD. At this time, probably in the mid-1920s, Addison Way was Adams Avenue. John Quincy Adams was the owner and developer of the land in this area to the east of Eagle Rock Boulevard. Addison Lee, for whom the street is now named, was an early resident on the street. (Courtesy Doris Thielen.)

JOHN QUINCY ADAMS HOUSE, 1962. Built before the turn of the 20th century, it had served for many years as the Cresse Mortuary, here as part of the Utter McKinley chain. The mortuary chain was later bought by the family business of Rick Gutierrez, an Eagle Rock High School graduate. It now houses a preschool.

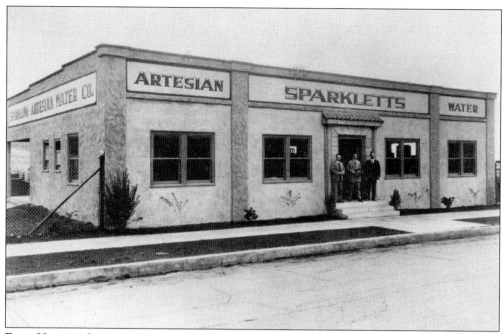

First Home of Sparkletts Water, 1925. Locals had long relied on an artesian well on swampy land in the York Valley for water in dry years. Burton N. Arnds and Glen Bollinger took an option on this source and, with one employee, began delivering bottled water in a ramshackle truck. The business continued to grow.

New Sparkletts Water Building Opens, 1929. Billed as "one of the largest plants in the world for bottling water exclusively for drinking purposes," this Moorish-style building had a festive opening, "No tanks, reservoirs filters or pumps are necessary in this companies' plant." The deep source is still used as one of the many producing for the Sparkletts brand today. Water is still plentiful in the valley as discovered by several contractors excavating, in recent years, for underground parking.

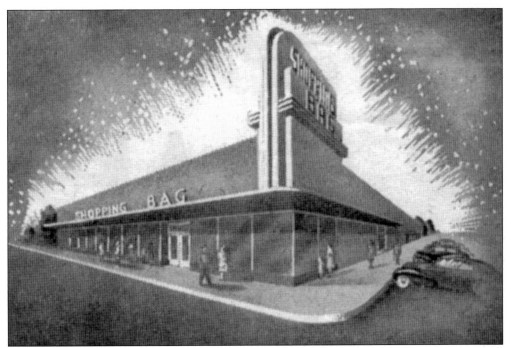

SHOPPING BAG MARKETS' FLAGSHIP STORE. "It is my hope that someday Shopping Bag can build a market to adequately fill the needs of the people of Eagle Rock, that community being our headquarters," said Mr. William R. Hayden in a conversation years before this market opened in 1948. Even larger markets became the fashion, and the building was sold to the One Day auto painting chain. This and other properties around it attracted developers who wanted to build a mall with a Walgreens store as their anchor. The building was demolished.

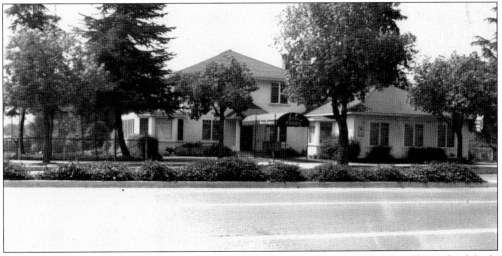

MARTHA WASHINGTON RESTAURANT. Shown when owned and operated by Ronald J. and Adelaide McNutt in 1946, the restaurant was a reuse of a large house built on Colorado Boulevard in the boom of the 1920s. Shortly after this, the area to the left of the canopy was filled with a less formal café dining space. It served as a community meeting place for many years. It was taken over in the 1960s by a group of lawyers, who renamed it the Barristers Inn. It continued to serve into the 1970s, when it closed.

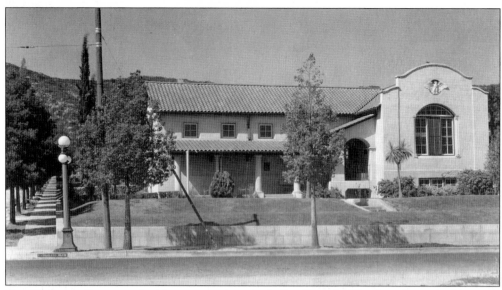

OLD CARNEGIE LIBRARY. A citizens committee including Blanche Gardiner, later the librarian, raised the funds for the building with the help of a grant from the Carnegie Foundation. It was constructed in 1914 after a spirited debate over its location. The books were initially from the County of Los Angeles. A controversy developed, and the county books were withdrawn. The library closed for a short time before reopening with books collected from Eagle Rock's citizenry. Charles Lummis, Los Angeles's first librarian and Southwest Museum founder, spoke at the reopening. (Courtesy Security Pacific Collection, Los Angeles Public Library.)

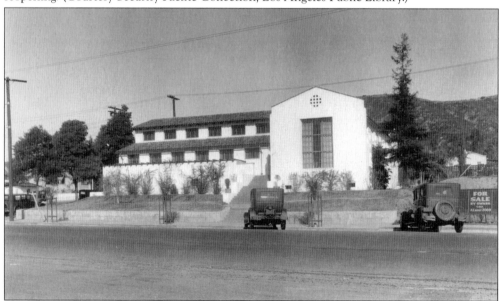

SECOND EAGLE ROCK LIBRARY, 1927. Now a branch in the Los Angeles City system, the old Carnegie Library was outgrown and worn out. Architects Newton and Murray rebuilt the library reusing the basement and foundation on the east side of the building, boasting of a savings of $10,000. This expanded facility was still presided over by Blanche Gardiner, who retired after long service in 1942. (Courtesy University of Southern California Library, California Historical Society Collection.)

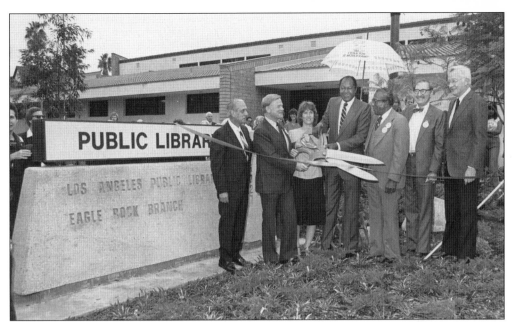

RIBBON CUTTING. By 1980, a new library was needed. A new, more accessible facility was constructed on Merton Avenue. Pictured here from left to right are Sen. Edward Roybal, Councilman Arthur K. Snyder, branch librarian Teresa Manix, Mayor Tom Bradley, board of library commissioner Frank W. Terry, television weatherman George Fischbeck, and city librarian Wyman Jones as they cut the ribbon on October 3, 1981. The facility boasted 12,500 square feet of space and could hold up to 72,800 volumes. (Photograph by Henk Friezer.)

BLUE-RIBBON COMMITTEE INSIDE RESTORED LIBRARY. A diverse group was selected by Councilman Richard Alatorre to discuss the use of the newly earthquake-safe historic building. The committee recommended a mixed-community use. This was modified by the city in a citywide effort to partner with regional arts education nonprofits. This partnership was the beginning of today's Center for the Arts, Eagle Rock. The building also houses the Eagle Rock Valley Historical Society archive.

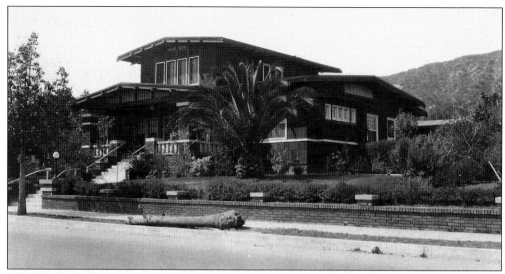

Col. James W. Eddy's Home. Eddy earned his rank in the Civil War. He constructed, owned, and operated the Angels Flight Railway beginning in 1901. He retired to this house in 1913 to be near his daughter Carrie. He was a founder of the chamber of commerce and vice president of the Eagle Rock Bank. His granddaughter Purle Gillette married Herman Hensel in the house, and they cared for Eddy until he was "Called Suddenly Hence" in 1916. The house on the corner of Eddy Street (now El Rio Avenue) was replaced by the Model Market, which was in turn remodeled into today's Bank of America. (Courtesy Rollin McNitt.)

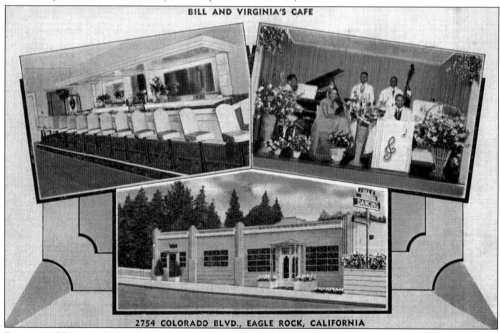

Bill and Virginia's Café. An early nightspot on the west end of town, the business may have been African American–owned, as it stood on property optioned from the Ellis ranch by James M. Alexander, a black man, in 1927. This purchase caused considerable concern in the community. For the most part, the "color line" was maintained in Eagle Rock by "gentlemen's agreement" until desegregation became the law in 1964. (Courtesy Stargel Collection.)

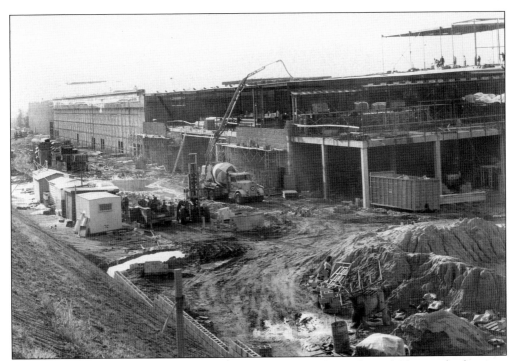

THE EAGLE ROCK PLAZA. One of the earliest regional malls, the Eagle Rock Plaza took advantage of shopping trends in the 1970s and the Route 2 and 134 Freeways also under construction at the time. It required the destruction of many residences and several large commercial buildings all constructed on the Ellis Ranch, subdivided over time. Ed Adams assembled the properties. The May Company in the foreground and Montgomery Ward in the distance participated in financing the project. (Courtesy Glendale Public Library Special Collections.)

BIRDS IN FLIGHT. Kate Pedigo shows her drawing to Evelyn Kilbrick, manager of the Plaza. The sculpture by Daniel Gluck was conceived as the central feature of the new mall, which filled a two-story escalator atrium. The sculpture was removed in a later remodel. Pedigo began her career late in life and paints in a "folk art" manner. She has participated in many shows, supervised the Eagle Rock historic mural series for the Eagle Rock Art Association, and written and published several books. (Courtesy Kate Pedigo.)

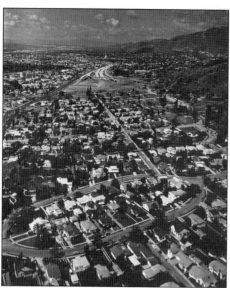

FREEWAY AIMS AT EAGLE ROCK. The completed Ventura (134) Freeway approaches from Glendale. The elevated ramp shows where the Route 2 Freeway will cross. The swath of homes has been cleared for construction. Three hundred homes were demolished in Eagle Rock for the 134 Freeway, but it could have been worse. About the same number were razed for Route 2. (Photograph by Joe Friezer.)

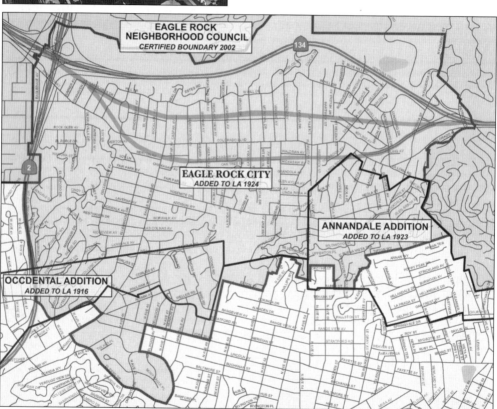

IS THAT IN EAGLE ROCK? It is a more complicated question than most realize. The map shows the border of Eagle Rock City, which was incorporated from 1911 to 1923. Parts of the Annandale and Occidental Additions have generally been said to be "in Eagle Rock." The Neighborhood Council process outlined a somewhat larger area in 2002, but some parts of the city have been demolished and some isolated by freeway construction. The thick grey lines are the freeway routes proposed in 1951; they resulted in a 15-year struggle for the town's existence.

126

BIBLIOGRAPHY

Batchelder, Elizabeth. *Solheim Lutheran Home: Its Life and Times 1923–1996*. Los Angeles: Solheim Lutheran Home, 1996.

Cleland, Robert Glass. *The Cattle on a Thousand Hills: Southern California 1850–1870*. San Marino, CA: The Huntington Library, 1941.

———. *The History of Occidental College 1887–1937*. Los Angeles: Occidental College, 1937.

Crocker, Donald W. *Within the Vale of Annandale: A Picture History of South Western Pasadena and Vicinity*. Pasadena, CA: self-published, 1968.

Galpin, Cromwell; Henry Welcome, ed. "Reminiscences." *Eagle Rock Sentinel*, 1913: published with introduction and notes, Eagle Rock Valley Historical Society.

Johnston, Bernice Eastman. *California's Gabrielino Indians*. Los Angeles: Southwest Museum, 1964.

Moreau, James, and James Walker Jr. *Glendale & Montrose*. Los Angeles: Pacific Bookwork, 1966.

Occidental College. *Occidental Fair*. Nashville: The Booksmith Group, 2008.

Rolle, Andrew. *Occidental College: A Centennial History 1887–1997*. Los Angeles: Occidental College, 1997.

Smith, Katie, and Joe Friezer (additional photographs by Henk Friezer). *Eagle Rock Then and Now*. Eagle Rock, CA: Eagle Rock Chamber of Commerce, 1987.

Swinnerton, Medora. *Eightieth Anniversary History of the United Church of Eagle Rock California*. Eagle Rock, CA: United Church, 1967.

Thompson, Nelda, ed. *Memories of Old Eagle Rock Told* (interview series). Eagle Rock, CA: *Eagle Rock Sentinel*, 1961.

Welcome, Betty; Henry Welcome, ed. *The History of Eagle Rock*. Eagle Rock, CA: Eagle Rock Valley Historical Society, undated.

Winter, Robert. *Myron Hunt at Occidental College*. Los Angeles: Occidental College, 1986.

Women's Twentieth Century Club. *The Women's Twentieth Century Club: History 1903 to 1953*. Eagle Rock, CA: Women's Twentieth Century Club, 1953.

www.arcadiapublishing.com

Discover books about the town where you grew up, the cities where your friends and families live, the town where your parents met, or even that retirement spot you've been dreaming about. Our Web site provides history lovers with exclusive deals, advanced notification about new titles, e-mail alerts of author events, and much more.

Find Your Place in History.